How to Capture
MOVEMENT
in your Paintings

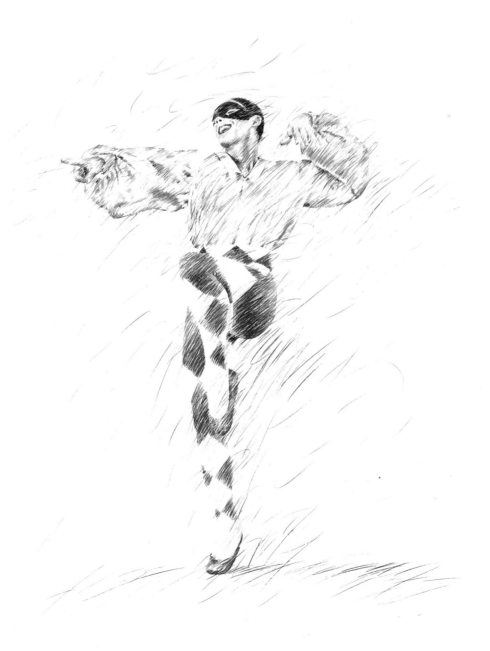

How to Capture
MOVEMENT
in your
Paintings

Julia Cassels

AURUM PRESS

A QUARTO BOOK

First published in 1996 by
Aurum Press Limited
25 Bedford Avenue
London WC1B 3AT

ISBN 1-85410-442-X

This book was designed and produced by
Quarto Publishing plc
The Old Brewery
6 Blundell Street
London N7 9BH

Assistant art director Penny Cobb
Senior editors Michelle Pickering, Maria Morgan
Editors Helen Douglas-Cooper, Susie Ward,
Diana Craig
Designer Karin Skanberg
Editorial assistant Judith Evans
Photographers Paul Forrester, Laura Wickenden
Picture researchers Jo Carlill, Miriam Hyman
Picture manager Giulia Hetherington
Art director Moira Clinch
Editorial director Mark Dartford

Typeset by
Central Southern Typesetters, Eastbourne
Manufactured by
Eray Scan Pte Ltd, Singapore
Printed by
Star Standard Industries (Pte) Ltd, Singapore

Harlequin

by Carl Melegari (page 1)

Spring Flowers II

by Jacquie Turner (page 2)

Monkeys

by Julia Cassels (this page)

FOREWORD

A large proportion of painting subjects involve some form of movement, whether you are tackling a street scene, animals, the human figure engaged in some activity, a landscape swept by the wind, or the shimmering effect of constantly moving light. Yet the successful evocation of movement within a painting presents a major challenge, even for experienced artists.

Until the late 19th century, artists portrayed moving subjects as static shapes. Often these interpretations were anatomically incorrect, resembling frozen images devoid of any impact or vitality. With the advent of the Impressionist movement, artists discovered exciting new tricks with colour, composition and painting techniques that enabled them to extend reality to suggest the illusory sensation of movement. By looking at the world in a new way, they shocked Victorian society with their novel and unconventional brushwork, innovative colour relationships and radical compositional interplay between shapes. And they achieved expressive and dynamic images that

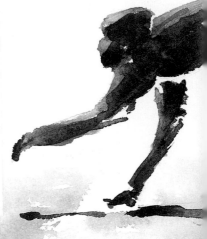

were electric with motion and saturated in atmosphere. Impressionism crossed a barrier, heralding a new age of expressive art. The simultaneous advent of photography dramatically increased artists' understanding of movement. For the first time, a galloping horse could be captured on film and its sequence of leg movements studied. There was no longer any excuse for horses to be portrayed with their legs impossibly spread-eagled in flight.

Some mediums and techniques lend themselves better than others to the description of movement, so it is useful to know the potential and special attributes of each medium, and to be familiar with using it, so that you can concentrate on the subject in hand. The benefits of each medium are explored, as are the four fundamental elements necessary to achieve an impression of movement: shape, colour, brushwork and composition. The second half of this book looks at how these four elements can be used to convey movement in a wide range of subject matter. As with all painting subjects, you need to make certain decisions before you begin. What style of brushwork should be used? How to interpret the interplay of colours and shapes, and their corresponding distortions, reflections and shadows? And how to organize a composition, locate the focal point and establish a viewpoint. If this sounds rather daunting, bear in mind that simplicity is the most effective approach. Simplify the subject, concentrating on the essential elements in the composition.

The work of many different artists with widely varying styles and techniques is reproduced and analyzed in detail to provide ideas and inspiration for this difficult but exciting and rewarding aspect of painting. It is important to experiment with different mediums and approaches, and projects and exercises are included in every chapter, together with lots of helpful tips, to help you put theory into practice.

Julia Cassels

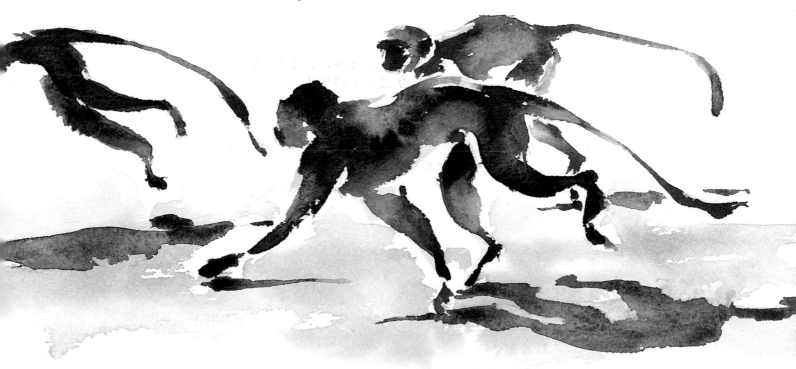

Contents

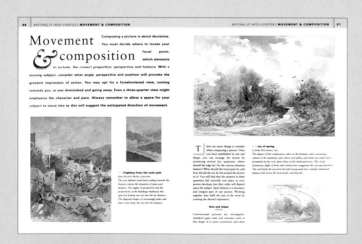

Introductions

Clear introductions to each theme plus inspirational paintings by artists working in different media and styles, each one analyzed with informative captions

SECTION

2

Putting it into practice
70

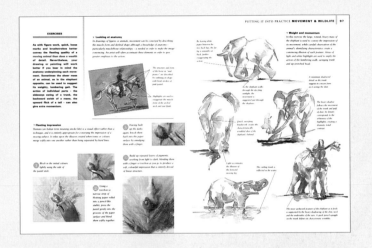

Exercises

Practical guidance to build up your technical and observational skills in relation to movement

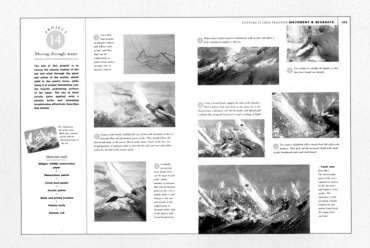

Projects

Step-by-step demonstrations which put what you have learned from the introductions and exercises into practice

Media & techniques

For centuries painting has been an elementary visual form of expression. The hunting scenes that adorn the caves of Stone-Age man, and the runners on the decorated pots of Ancient Greece are among the earliest forms of art that depict movement. Over the years styles and techniques have been adapted by changing civilizations, and artists' materials have become progressively sophisticated. Of the multitude of media now available, each has a particular character that can be exploited through different techniques. Explore the parameters of each to develop your own vocabulary of techniques.

Sticks of charcoal

Each painting and drawing media – pencil, charcoal, pastels, watercolours, gouache, acrylics, oils and printing inks – has special characteristics. Very different techniques, therefore, can be used with each to create the impression of movement. It is important that you get to know the characteristics of your materials and the different ways in which you can use them so that if necessary you can work fast and instinctively to capture a moving subject or a fleeting effect.

Pencil
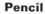

Pencil is highly responsive to the slightest movement by the artist. Its linear quality can perform a catalogue of expressive, gestural strokes, that are ideal for describing movement. A wide range of tonal effects can be achieved with directional hatching, graduated shading, smudging or random strokes applied with varying intensity. The softer the pencil, the greater its textural grain and potential for smudging and blending.

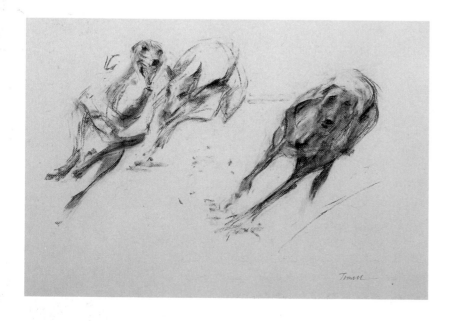

◀ Charcoal
The fluid lines of movement are strongly defined with sweeping strokes of the tip of the charcoal stick. Muscular form and structure – particularly evident on the leading dog – is delicately smudged with a finger. On the second dog the smudged areas describe the shadows, while the detail on the last dog diminishes almost to a linear sketch. (On the bend, Jonathan Trowell)

◀ **Pastels**

By cross-hatching, smudging, or overlaying colours, the building remains oscillating and alive against the rhythmic elliptical strokes of the undulating water. With the end of the pastel stick, dabs and spots of white produce an infectious sunlit sparkle over the gondola and water. (The gondola, David Mynett)

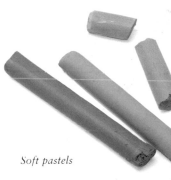

Soft pastels

Hard pastels

Pastel pencils

Charcoal

Charcoal can create a delicate and smokey effect when swept softly over the paper, or a dramatically dense and dark one when used with pressure. By using either the tip or the side of the charcoal stick, you can produce a range of marks that can then be smudged, flicked over with a brush, or drawn into with an eraser. Compared to the linear precision of pencil, charcoal is less controllable, but more versatile. It is a superbly sensuous and fluid medium, spontaneous and immediate, and ideal for capturing a subject quickly.

Pastels

Of all the colour media, pastels provide the artist with pigment in its purest form. The loose, crumbly nature of pastel means that it goes on unevenly, giving texture to blocks of colours and this is further enhanced by the rough surface texture of pastel paper. Their sensitivity to changes in pressure and direction, and the potential they offer to combine large areas of colour with expressive drawn marks, makes them the ideal tool to capture the transitory effects of movement. You can build up a range of techniques simply by turning and twizzling the pastel stick.

The tip and the sides can perform a variety of stabbing strokes, dots, broad sweeping lines, and blocking tones. Linear strokes made with a blunt end, sharpened tip or side of the pastel lend calligraphic rhythms and directional momentum. By dragging a pastel stick on its side across the paper you can block in a moving subject very quickly. It can then be smudged or blended. Layers of colour can be built up using "feathering" (directional hatched strokes); "scumbling" (moving the side of the stick in a loose motion); "impasto" (heavy layering into relief); and *sfumato* (smoke-like merging of colours into each other).

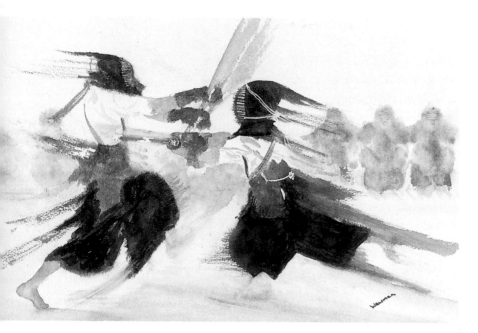

*Watercolour pans and
fine sable brush*

◄ **Watercolours**

*A terrific sense of power and impact as the
fighters clash together is derived through the
effective gestural sweeps of the artist's dry brush.
The fragmented textural wisps of colour draw us
to the focal point of the action, which in the
muddle and confusion of speed, is conveyed in a
blurring of washes allowed to bleed together.*
(Kendo power, *Glen Wawman*)

*Tubes of
watercolour*

*Watercolour palette
and round-ended
sable brush*

Watercolours

Watercolour is perhaps the most immediate and exciting of all paint media. No other pigment mixture compares in pure clarity of colour. The joy of watercolours lies in the way that they can be used in a loose sketchy way to capture a mood and evoke an atmosphere. Artists evoke these effects by using a combination of techniques.

Before starting, however, it is a good idea to learn which pigments are translucent and which are opaque. Paint a wide line with waterproof black ink or felt-tip pen, then paint a swatch of each pigment across it and compare the extent to which the black line shows through different colours. As the cobalts, vermillion, cerulean blue and yellow ochre are virtually opaque, the black line will hardly show at all. The cadmiums, naples yellow and alizarins will appear less translucent than colours such as viridian, cobalt blue or aureolin yellow. The degree of translucency will vary according to the make of your paints.

The most important grounding of watercolour is the "wash". Washes are broad areas of uniform tone laid with either a large brush or sponge. Layered washes of pre-mixed or diluted colour establish a more static setting. Watercolour can be applied in four different ways: wet in wet, wet on dry, dry brush and dry on wet. Ideal for expressing the effects of movement, the technique of directly applying paint into pre-wetted paper can produce wonderful dispersed random blurrings of strong or weak colour.

By controlling the pressure and wetness of the brush, the artist can suggest a sense of pace and form. A wetter brush with weaker pressure will convey a feeling of distance with the indefinition of form to imply the pace of movement. A drier brush with more forceful brushstrokes will describe the form, its action and direction with greater clarity by less depth. Combining wet and dry brushwork with strong and weak brush pressure enhances the action within the picture by identifying the movement with a three-dimensional realism.

Watercolour's luminous nature accommodates the paper tone, revealing it through thin washes, or leaving well-judged areas unpainted to form highlights. Its spontaneous character inspires fast thinking between areas of broad wash and more decisive brush strokes. You should never try to produce a tight, controlled image, and this is especially so with moving subjects. Instead, exploit watercolour's unpredictability and make the most of accidental effects.

Gouache

Gouache is extremely versatile and often used in conjunction with other mediums. It can be used to paint large areas of flat colour, or, for full, dense, rich tones it can be "impasto" (applied very thickly). The opacity of gouache permits lighter colours to be painted over dark, obliterating the darker one completely. Thinned with water, gouache can create as translucent an effect as watercolour and you can employ many of the same techniques to achieve similar effects. However, its opacity adds a new dimension, allowing a wash or thick line to be painted over another without disturbing or revealing it. A build-up of thickly applied gouache can produce superb examples of impasto. Gouache is fun to experiment with and is an excellent medium in which to get the "feel" of colour.

Mixed media

Often highly expressive and exciting, mixed media infuses a painting with emotion and mood. Acrylics, watercolour, wax crayons, chalks, pastels and charcoal are just some of the materials used in mixed-media work. Many combinations, such as oil pastels and watercolour, produce unpredictable results that are particularly effective for portraying a moving subject such as water or a windswept landscape.

Tubes of gouache

▼ Mixed media

Initially painting the shapes of the boats, sails and people in gouache, the texture is built up with oil pastel and acrylic, until the foreground becomes a choppy sea of frantic impasto wax. The detailing on the sails and figures is sketchily drawn with oil pastel, while in the distance the pastel is smudged into the gouache to produce a blur of colour and inspire the illusion of depth in the busy all-moving scene. (Sigmas racing, Jacquie Turner*)*

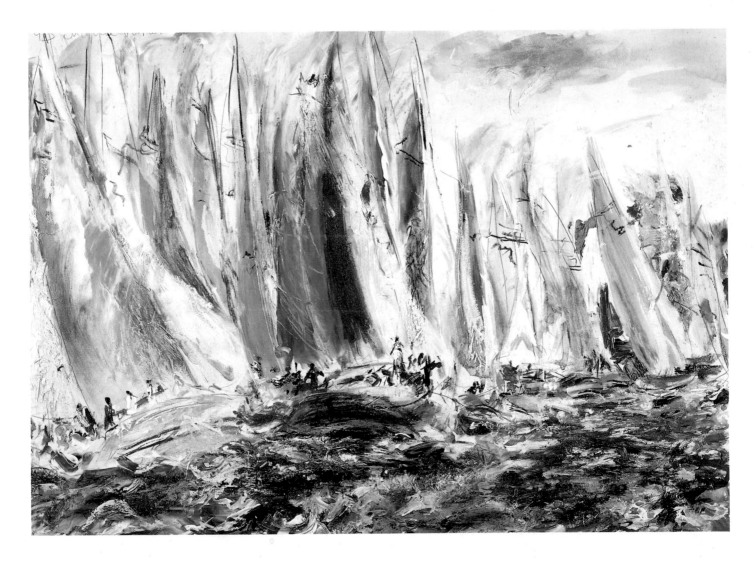

Acrylics

Acrylics are synthetic paints whose glossiness lends plastic brilliance to the colours. Being water-based, they work in a very similar way to watercolour and gouache, and employ the same types of paper and brushes. The colours are transparent, but quick-drying, and thus allow only a short time to mix and blend but they can be painted over. Like watercolour and gouache, acrylics can be thinned to form washes, or mixed with glaze mediums to produce intense and colour-rich transparent glazes. They are used to best advantage when thickly applied to form impasto. You can add texture paste to the paint in order to apply it very thickly, and then carve into it while it's still wet with a palette knife or brush to sculpt the forms, using quick, loose strokes that follow the direction of movement.

Oil paint, canvas and square-ended brush

Blending oil paints with a palette knife

Oils

When using oils to paint a subject that involves movement, there are two approaches that enable you to capture it quickly. You can begin with a monochrome underpainting and then build up layers of colour over this when it is dry, or you can work wet into wet, or *alla prima*. A mono-chrome underpainting, which should be made with thinned-down paint, allows you to capture the bare bones of the subject quickly, fixing the lights and darks and the tonal values of all the main areas in the composition. It also enables you to establish the spirit and mood of your intended picture. When this is dry you can build up the painting with layers of colour, using the tonal underpainting as a guide. Work quickly on this second stage to retain a sense of liveliness and energy.

The Impressionists ignored the traditional technique of building up layers of paint. They worked an impasto of wet into wet, allowing the colours to blend together on the canvas. This method, known as *alla prima*, allows you to exploit the fluidity of the medium by working rapidly and was ideal for the Impressionists in conveying their fleeting images.

"Scumbling" is used in a similar manner to its use in pastels, by laying an opaque colour roughly over a semi-dry area and allowing the lower layer to show through brokenly. Other varying textural effects can be achieved through the methods of *frottage*, *sgraffito* and of course *impasto* used with other mediums. The first, frottage, uses paper to dab a partially dry area. The oil paint sticks to the paper, dragging the

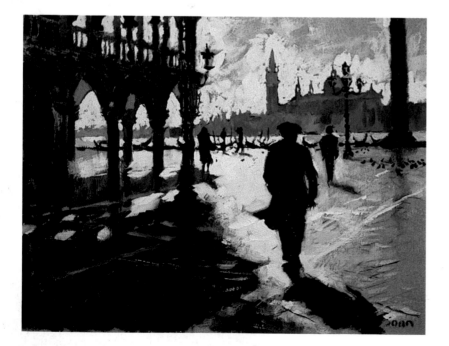

◄ Oils

The power of the wind is reflected in the puffy white impasto sky. The strong almost monochrome use of contrasting colour directs our attention towards the gondolas basking in the white light, in the same path as the black-shadowed walking man. The irregular colours of the building's reflection in the wet square contribute to the atmospheric impression of windblown motion. (Crossing St Mark's Square, Venice, Hazel Soan)

Acrylic paint with round and square-ended brushes

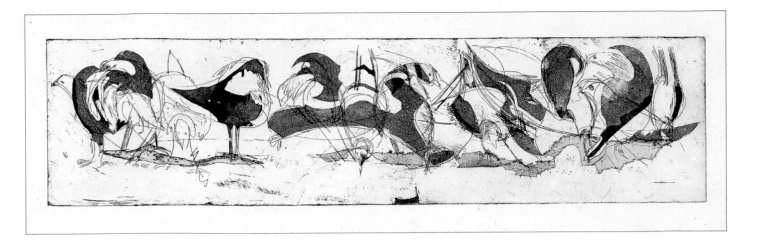

surface when lifted off, like a lid of an ice cream tub. Sgraffito is the drawing into wet oil paint to reveal the underlying colour. As with pastels, you may well develop your own tricks of extracting the best effects from oils. Its compliant nature is enjoyable to play with and the results can be hugely satisfying.

You need many more brushes for oils than for water-based paints, otherwise you will be forever cleaning and drying them. They are almost double the length of watercolour brushes, so that you can stand back as you work – essential if you are working on a large canvas as it enables you to see the picture as a whole while you work. Brushes for oils come in a variety of shapes and sizes and are traditionally of hog's hair. You will find that their different shapes suit a range of techniques – square-ended for blocking in, stabbing and directional strokes, pointed for detail, and rounded for thin glazes or for layering paint into impasto. The palette knife is another invaluable tool. Its springy, flexible steel allows you to mix your paints and clean your palette, as well as acting as an effective tool for applying the oils themselves. Oils can be painted onto a variety of surfaces, from hardboard, cardboard and walls to paper- and linen-covered boards. Each surface affects the appearance of the oils. Canvas yields to the paint, holding it well in its texture, while primed boards allow the paint to slip about over its surface. Experiment with different surfaces to find the one that you feel most comfortable with.

▲ Printing

Creating the feeling of motion in an etching is certainly a challenge. This intaglio etching demonstrates that by using a variety of printing techniques, it is possible to create the active sense of movement. The sweeping linear curves, deeply bitten into the plate, enliven the static solid tonal aquatinting, inspiring the image into one of chaotic motion. (Pigeons, *Kate Song-Teale*)

Monoprinting

Monoprinting is the one printmaking method that is particularly well suited to portraying movement. Using either etching or litho inks mixed with turpentine and oil, the artist paints an image onto a smooth surface – usually a metal plate or glass. With a metal plate, the image is transferred onto paper by rolling the plate and paper through an etching press. With a glass plate, a litho roller or even a kitchen rolling pin can be used. As the oil allows the inks to spread and the turpentine dilutes them, the resulting image is always spontaneous. Explore the various paint media to find the one with which you feel most at home.

Smearing printer's ink onto glass before rolling onto paper

SECTION

1

Putting it into context

As you think about the picture you are about to paint, look at your subject in terms of its context: the overall framework of the composition; the relation of one figure or object to another and their position within the scene; the speed of movement; and the type of light and its effect on shadows and tonal values. This section of the book examines how to observe and analyze a subject in terms of shape, brushwork, colour and composition.

▶ Clockwise from top left:
Skopelos sea *Annie Woods,* **Horse race** *Constance Halford-Thompson,* **Blue parade** *Rosie Sayers,* **Building sandcastles (detail)** *Tom Coates,* **Going up Berthoud (detail)** *Doug Dawson*

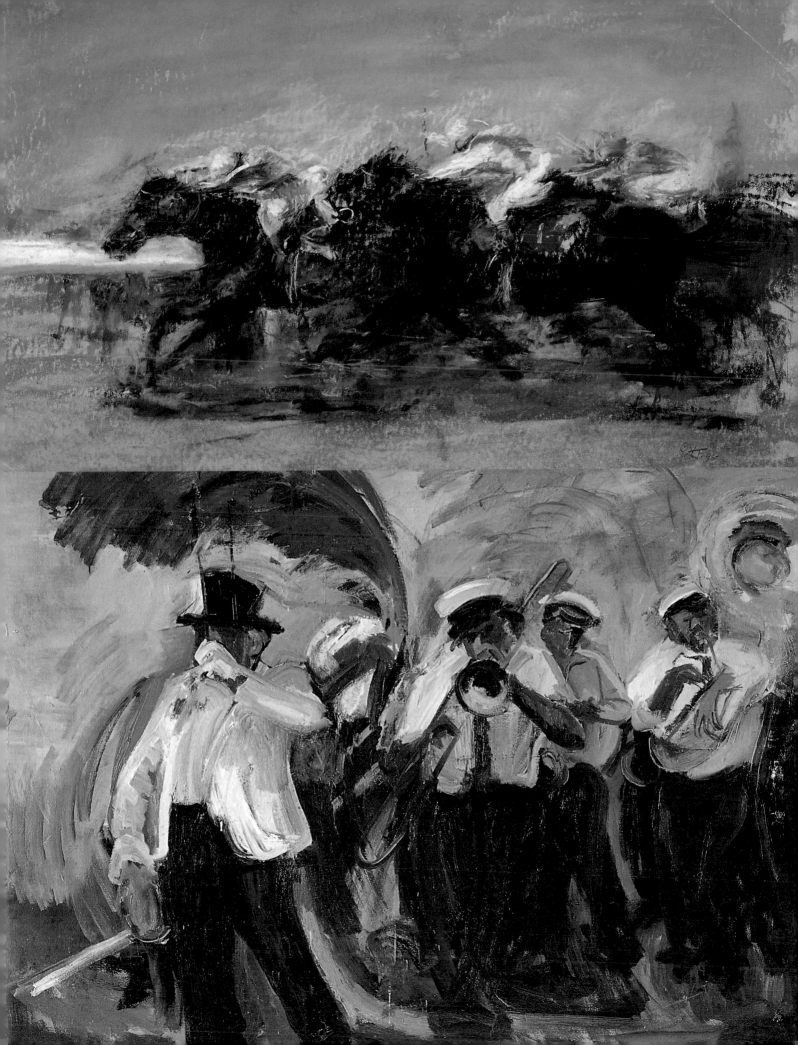

Movement & shape

The first thing we notice in a moving object is the shape of that movement. Some things actually adopt new shapes when moving. We all recognize the forward inclination of a person, or the elongated form of a dog, when running. Likewise, a bird completely transforms its posture – from being upright when standing, to extending horizontally when in flight. The shape identifies the subject, so that we recognize it within the context of movement. How you convey the shape and the reality of this movement will rest on your understanding of your subject's space, volume and solidity within the composition.

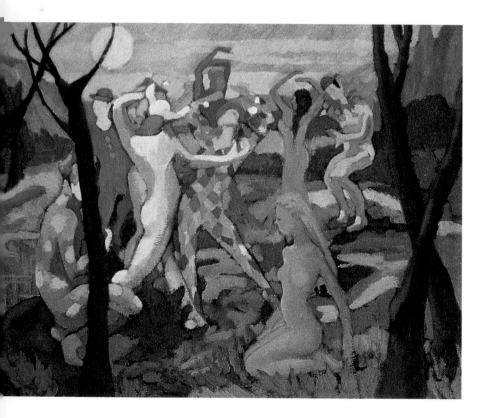

▲ By the light of the moon

OLWEN TARRANT, OILS

The shapes of the dancing figures are depicted in flat, vibrant colours, their warm tones contrasting with the cooler greens of the background. The movement and rhythm are emphasized further by the curving contours and shapes of the arms and legs.

W hen we talk of the "shape", we mean the mass, the entire form. In other words, capturing the outline of the whole image as it moves. Being able to recognize this outline is the first step in assessing your subject – like recognizing the curve of a breaking wave. In drawing the shape, you are merely fixing its position without, at this stage, incorporating other composite elements: form, colour, light and shadow. Shapes, either overlapped or placed side by side, can evoke movement through

The wonderful, curvaceous shapes, from headdress to thigh, emphasized by their whiteness, dictate the momentum of the picture.

The coloured shapes of the background and the dancers' shadows correspond and reflect the circular motion of the dance.

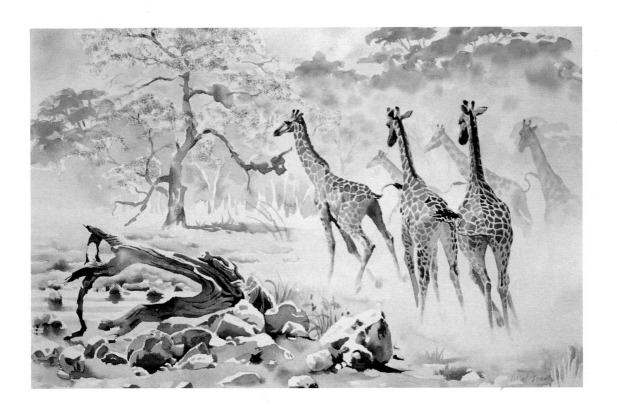

◀ **Taking flight**

HAZEL SOAN,
WATERCOLOURS
*In this frozen instant
of action, the off-
balance shapes of
the giraffes, their
extended necks
and tangle of legs
all convey the
impression of panic
and flight. The
increasing angle
of inclination of
the giraffes in
the foreground
leads the eye in the
direction in which
they are moving.*

*The strong, static
shapes in the
foreground emphasize
the movement of the
giraffes away towards
the middle distance.*

*The angle of the
leading giraffe suggests
that it is turning at
speed.*

*The fading legs
concealed in dust
convey the fast speed
at which the giraffes
are moving.*

the angles at which they are set, both in relation to the ground, or the base of the picture, and in relation to each other. Take a look at Matisse's *The Dance* (1910), with his sinewy orange human shapes dancing in a circle. Their curving arms, legs, and bodies emphasize and exaggerate the energetic rhythm of their circular motion.

Observation

When observing a subject, try first to analyze its shape. Consider where your main feature should be placed within the picture area and how much space it should occupy, since it is the vital component of your composition. If your subject is a person or live creature, a knowledge of anatomy is a great advantage for recognizing the shapes your subject could realistically assume in movement.

Authenticity is the key word when attempting to paint a moving subject. It is very easy to have misconceived ideas of how you think your subject appears while moving. If you have ever really watched race horses at the gallop, you will have noticed how their legs bend at bizarre and improbable angles. Such transfigured inelegance enables their

undisputed speed. Look at how an angry provoked goose in profile will flatten its back and stretch out its neck to resemble a pouring tea-pot!

The proportions of certain things change when they move. Something stationary may look odd, or completely out of proportion, but it often changes into a perfectly balanced shape when motivated. If you were to accurately depict a cheetah sitting, its naturally small head might appear as an artistic error. But when running at full pelt after its prey in a tangle of legs, with its neck and long sinewy tail out-stretched, the

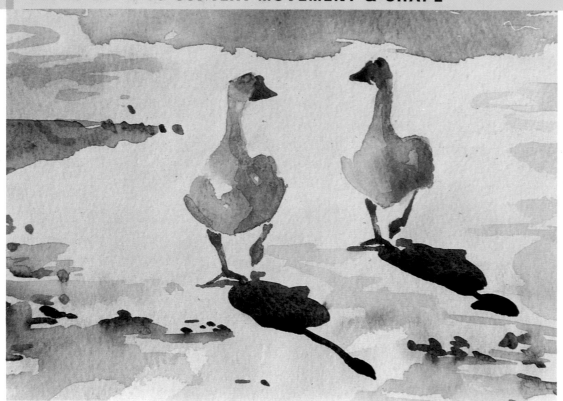

◄ **Goose step**

JULIA CASSELS,
WATERCOLOURS
*The shapes created
by the light are used
to portray the
waddling geese. The
dark greeny/blue
shadow at the top of
the picture contrasts
sharply with the
warm, pale, saffron
light of the central
ground. This creates
an illusion of space,
and dramatically
illuminates the
moving geese.*

The artist has
concentrated on the
shapes and contours of
the ducks' forms.

By allowing a space
between the foot and
the shadow, the artist
shows that the leg is
obviously raised in
movement.

The unpainted areas
capture the impression
of sunlight and at the
same time describe and
complete the outlined
forms of the geese.

By leaning forward,
the duck has almost
formed a ball.
Together, the ducks
create an interesting
composition, the beak
of the upright duck
leading the eye down
to the crouched duck.

▶ **A pair of ducks**

ANNABEL PLAYFAIR, WATERCOLOURS
*While the geese above resemble upright "pear"
shapes, and their beaks stalks bending left and
right, the ducks are far more rounded and static.
These two pictures demonstrate the importance
of observation: the ducks seem to squat down on
their haunches while they rest, and elongate
themselves when walking.*

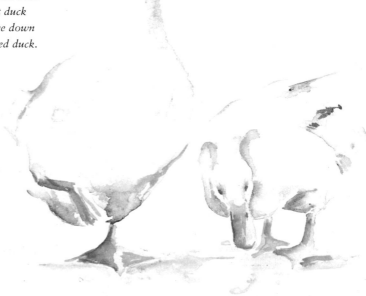

cheetah creates a moving image making perfect sense. Similarly a giraffe's long roman nose and angular head seems to outweigh such a tall slender neck when the animal is stationary. When it moves, with its neck extending and contracting, the head appears balanced and in proportion. We often assume the shape of a pig to be a squat, plump form perched on little legs, but if you look carefully, they have large ears, long faces and surprisingly long legs. And when they move, their ears flap about, diverting attention from their outsized proportions.

This change in proportion is far more obvious in birds than animals, as birds totally transform their shape in flight. Remembering that they were designed to fly (apart from the odd exception), it is hardly surprising how natural and at ease they appear in the sky compared to the ground. The spectacular shape they assume in the air is in utter contrast to that when we see them awkwardly hopping about on the ground, with their wings folded. It is not easy to study them in the air, but one of the key points to look for is the breadth of the wingspan in relation to the length of the body.

We can identify many birds by the shape they make while flying. A swallow's arched wings and forked tail are immediately recognizable; a flamingo in flight forms an evocative pink cross which diminishes into a trail of deep red legs. Birds of prey, soaring effortlessly on wind thermals, character-istically display a square-rigged wingspan fringed at the ends with upturned feathers.

Cartoonists exploit these shapes, mimick-ing their subjects with often hilarious exaggerations. With familiar subjects we are able to recognize the shape of their move-ment, but if the moving image is portrayed wrongly, it becomes impossible to accept its depiction as at all believable.

Shape and colour

Aerial perspective – the use of progressively lighter and less contrasting tones and paler colours towards the horizon – can be employed to relay the depth of a moving

The treatment of the various shapes triggers an oscillating, rhythmic effect, as if the landscape were vibrant and alive.

The bands of colour – rust, dark green and purple – indicate the varying depths and distances within the picture.

In isolation, these shapes appear abstract. As a whole, they form the base of a tree against the pale foreground.

By depicting a patch of foreground in shadow, the artist draws our attention to the middle distance.

▼ **Abstract landscape**
JANN T. BASS,
PASTELS
Strong shapes are the dominant theme of this pastel. The bands of juxtaposed colours create a landscape that is almost abstract. Realistic, representational form has been taken over by colour and the shapes that describe the landscape.

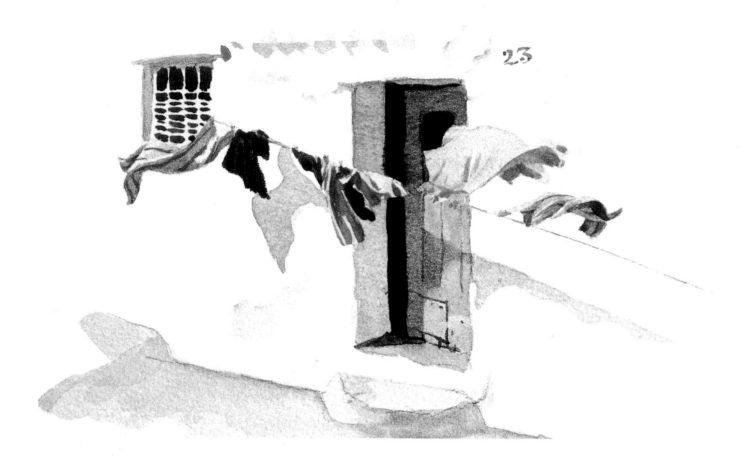

The peculiar shapes of the wind-blown washing inspire a realistic impression of movement, compared to the regular shapes of the door and window.

The wonderful, abstract shape of the dark blue shirt is exaggerated by its shadow on the wall.

We can almost feel the wind through the curving shapes, which are erratically forming new colours and images as they move through the light.

▲ A bigger puff of wind

HAZEL SOAN,
WATERCOLOURS

The recognizable solidity of the door and window form a wonderful contrast with the wild, transfigured shapes of the billowing washing. The unidentifiable forms evoke fantastic sensations of movement, magnified by the exaggerated shapes of shadows on the wall.

subject within the scene. As each object also projects a shadow, by overlapping shadows you can also effectively describe their distance from one another. Imagine a landscape of fields and trees disappearing into hills on the horizon. Ribbons of colour interpret the gradations of distance and site their location within the vista. A faint blue wisp of the hills in the distance, overlapped by a tagliatelli strip of darker blue, informs us that the paler hills are set further away.

Washing on a line blowing in the wind will be forced into completely different forms. It is as if these limp and lifeless articles of clothing become animated into a frenzy. Influenced into new shapes by means of colour, we hardly recognize the shirt, dress or trousers for what they really are. In this situation, the artist literally records the tonal shades of shapes as he sees them.

The colour of shapes also changes in movement, sometimes dramatically. When

poplar trees blow in the wind, the undersides of the leaves flutter with captivating anaemicness, resembling a shimmering shoal of silver fish. The open wings of a butterfly reveal amazing colours of which, when closed, we are given no hint. A peacock is perhaps the most spectacularly dramatic of all animals, with its tremendous display of iridescent "eyes" in its fanned tail feathers.

Shadows and shape

Shadows projected by their subjects form shapes of their own. They are not strictly representational for, depending on the angle of the light, they are either stretched or foreshortened. Despite the misshapen image, in strong light we can clearly define the shape of a tail, foot, fingers or strands of hair. A clever artist can convey the subject's position by the placement of the shadow. If the shadow connects with its subject, this indicates that the subject is on the ground – standing or walking, for example. Whereas, if the artist allows a certain space between the subject and its shadow, we can assume the subject is airborne – flying, running or jumping. However, it is the very distortion of shadows that convinces us of the reality of movement. Whereas a static object casts a clearly defined shadow that softens gradually the further it is from the object casting it, a moving object casts a shadow that is at least distorted in shape, and probably very fragmented and blurred.

Shape and composition

An outlined shape fixes an image within the composition. Other shapes relating to it must correspond in position and space. So the cumulative series of shapes affects the size, depth and distance, and relayed action of the painting. Try to regard the essence of shape as the first stage in compiling your picture. Shapes are the foundations for describing the situation or the style, type and pace of movement. Without such initial shapes the artist will be unable to build a well-composed picture.

▼ **Beach birds**

CAROLE KATCHEN, PASTELS

The fluid curves and voluminous shapes within the figures are exaggerated by the black swimming costume and red bikini. The composition of their body shapes and their poise evokes the subtle wit within this picture.

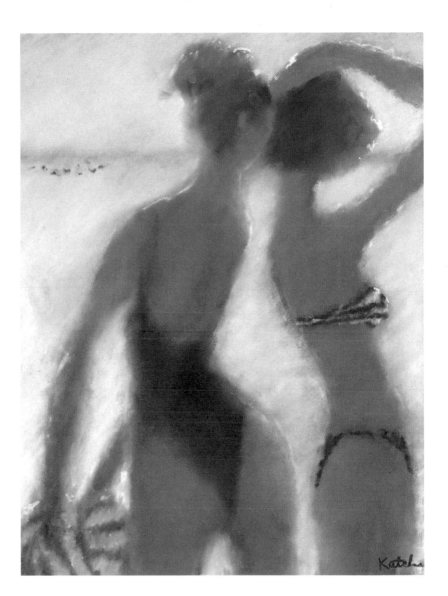

The artist has used the undulating shape of the black swimming costume to magnify the rotundness of the body.

The upturned "smile-shape" of the red bikini subtly enhances the concave stomach and conical thigh.

The human figure and those of animals and birds are incredibly flexible forms. When in motion, the separate parts of the body move and change shape, extending out into the surrounding space, contracting into a tightly defined area, twisting or bending. As the individual parts change shape, so the overall outline of the subject alters, too. When depicting movement, first establish the mass form of your subject – the geometric shape which it creates – and then look for the powerful linear rhythms within that mass.

Changing forms

Animals, birds and figures move by fluidly contracting and expanding their body shapes. Although machines and objects don't change their physical shape, their motion can be understood from the way in which the things around them react. Watch your own subjects to notice new twists, extensions and forms created by movement.

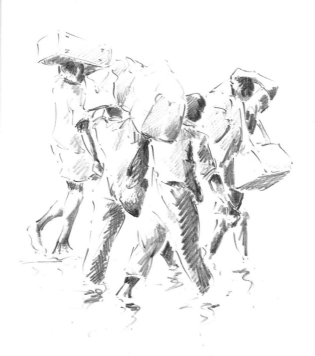

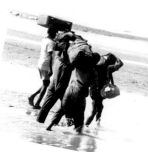

◀ *In a group of people walking, the varying shapes formed by the figures can best be seen by comparing one against another. The two central figures are captured at the same point in their swinging strides, while the other two figures form the beginning and end shapes of the strides.*

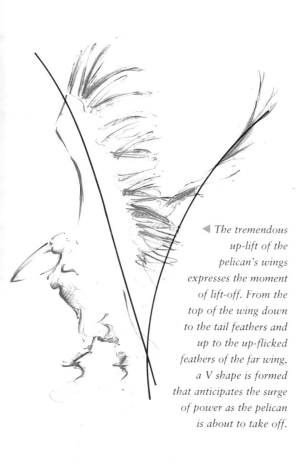

◀ *The tremendous up-lift of the pelican's wings expresses the moment of lift-off. From the top of the wing down to the tail feathers and up to the up-flicked feathers of the far wing, a V shape is formed that anticipates the surge of power as the pelican is about to take off.*

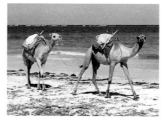

▼ *The shape of movement is clearly evident in these two camels. The leading camel forms a large open triangle as it strides forward, while the other one has a more contorted shape. The two together create a sinuous, interchanging rhythm of opposing contracting and expanding shapes.*

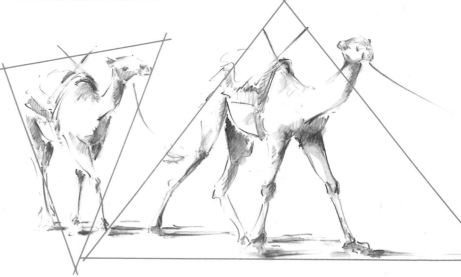

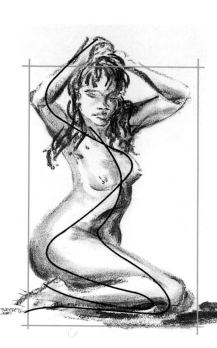

Inner rhythms

The sinuous muscle form and the skeletal structure can twist, bend, extend and fold to create a variety of shapes. Begin by visualizing the shape – such as a square or rectangle – into which the figure fits, and then identify the line of movement within the pose to understand the flow and rhythm of the figure's action.

◀ The pose is contained within a squat rectangle. By following the line of movement through the figure, you can interpret the twist of the torso and voluminous form of the thigh.

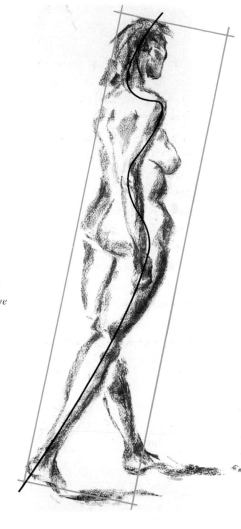

▶ The tilted rectangle is synonymous with the figure's forward movement. The fluid line through the pose hardly curves as it veers downwards on the diagonal towards the point of impact – the raised heel.

▼ The upturned triangular shape created by the outstretched arms emphasizes the swinging lift of the pose.

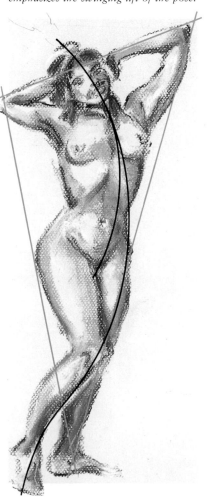

▶ This pose fits into an equilateral triangle, which is very static, but the concave twist of the spine and the rounded sweeping curve of the buttocks create a rhythmic S.

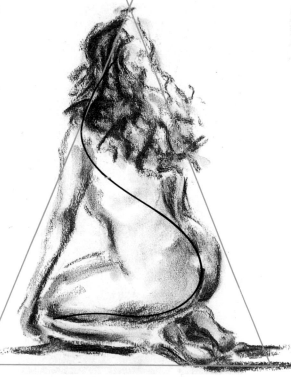

▲ The same pose from a different angle creates an entirely different shape and the line of movement is far more undulating.

1

Shapes and reflections

A moving subject can be conveyed not only through the relative positions of one shape against another, but also by showing the effect that the subject has on its surroundings. In this case, the river surface is disturbed by the elephants moving through it, and the reflections of the elephants have become very diffused, fractured and distorted.

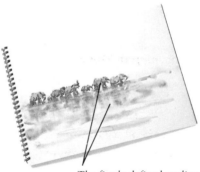

The firmly defined outlines of the elephants contrast with the blurred edges of their reflected images.

Materials used

500g/m² (240lb) watercolour paper

•

Watercolour paints

•

Sable brushes

•

Scalpel

•

Sponge

•

2B pencil

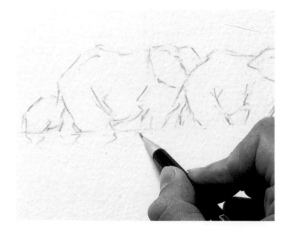

1 *Make a quick sketch of the outline shapes of the elephants to position them on the page. This will give you a framework within which to apply colour.*

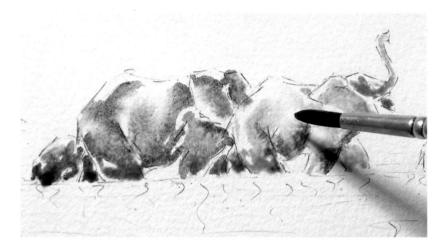

2 *Wash clear water across the elephant shapes, leaving selected areas dry to form the highlights. Feed washes of yellow ochre and light red into the wet areas and let them spread. Then apply a darker tone to give the shapes a sense of form.*

3 *When the paint is dry, cover the background and foreground areas with water. With a large brush and small sponge, bleed washes of blue into the water to form the river, trying to avoid the areas where the reflected shapes of the elephants fall.*

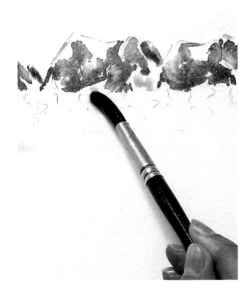

4 *Apply the earthy browns of the elephants' reflections and let them fuse and blur into the blue river. When the paper has dried a little add the darker tones in the reflections.*

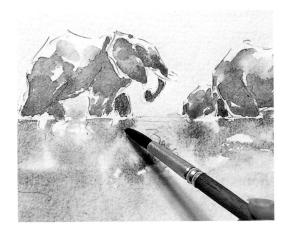

5 *Use a sponge to wipe out some of the colour in the river. This will create authentic watery highlights without leaving any hard edges.*

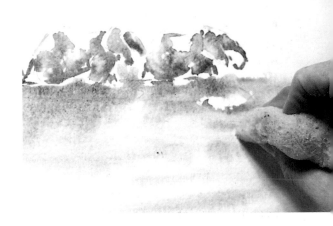

6 *Complete the outlined shape of the elephants with a pencil to emphasize the highlights. When the paint is dry, drag a scalpel across the most disturbed water to produce realistic sparkling highlights.*

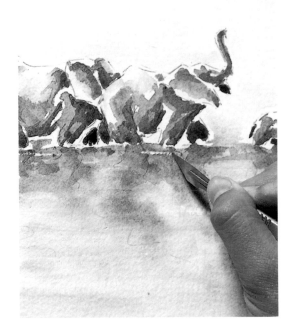

▼ Crossing the Luangwa River

JULIA CASSELS

In this comparison between solid shapes and their unsolid reflections, the warm reddy-browns of the elephants rebound off the cool blues, and their voluminous forms and lugubrious movement are accentuated against the water's surface.

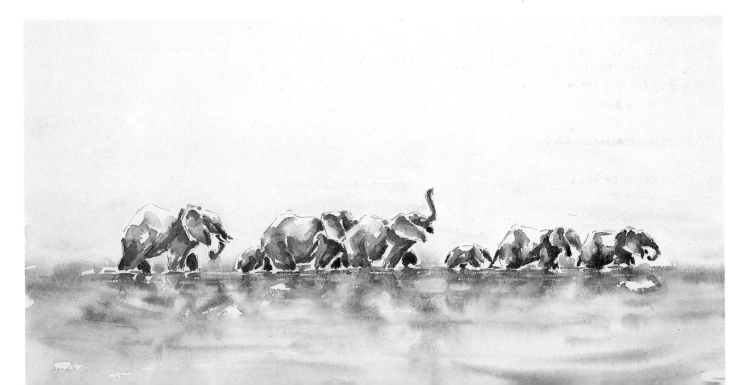

Catching a moment in time

Objects move because an external force acts on them. And when objects are moving, they become animate and even take on new shapes – such as trees blowing in the wind, or washing drying on a line. It is the new forms, shapes and angles adopted by the object that convey the movement.

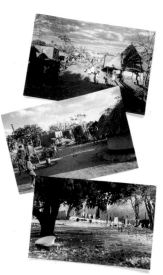

Elements from all three photographs are incorporated into the composition. The way in which the harsh African light and long deep shadows affect the various features in the scene is evident in these photographs.

Materials used

Watercolour block

•

White acrylic gesso

•

Oil paints

•

Small nylon brushes

•

Palette knife

•

Turpentine

1 *Prime the watercolour block with white acrylic gesso and allow it to dry. Then make an under-drawing using raw sienna diluted with turpentine.*

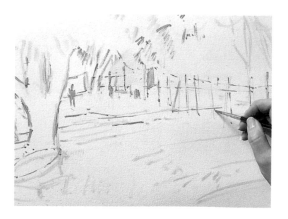

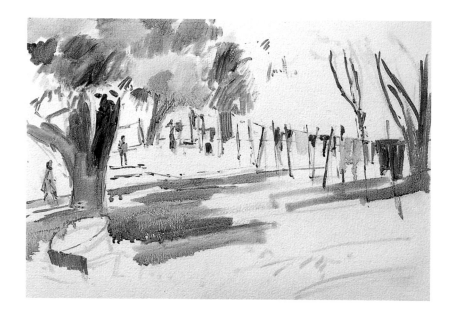

2 *With the initial shapes of the trees, people and washing line drawn in, block in the different tonal areas using very diluted paint for the lightest areas and thicker paint for the dark areas.*

3 *Block in broad sweeps of purple shadows in the foreground. Paint streaks of highlights where the sun shines through the trees.*

4 Build up the heavy branches and foliage of the trees with rich greens and browns and broad directional brushstrokes.

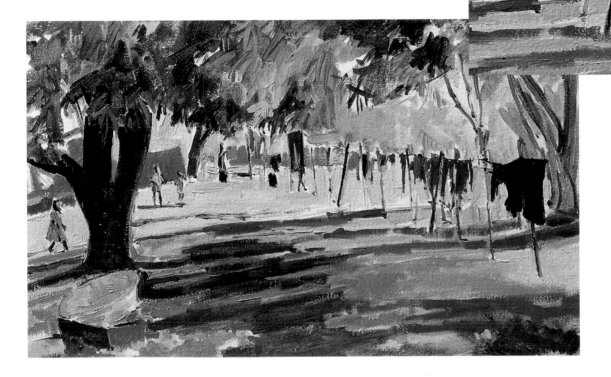

5 Begin to add more detailed colour to the washing line, still keeping the shapes loose to maintain the illusion of flicking motion in the breeze.

6 At this stage, with all the preliminary tones, shapes and colours in place, the picture should be infused with atmosphere. Warm lines and stark contrasts radiate the sun's heat as it plays along the washing on the line. By diminishing clarity and detail into strokes and dashes of juxtaposed colour in the distance, you can create a marvellous feeling of depth.

7 Pick out the foreground detailing of the leaves and their highlights with light and dark colour, making short strokes with a fine brush.

8 *Mix purple with flake white, which produces a translucent quality, and paint shadows under the washing line. Paint the trunk of the tree on the right a reddish brown. The colour should be light enough to show that the sun reaches it and that it is farther away than the other tree but deep enough to provide visual balance to the composition.*

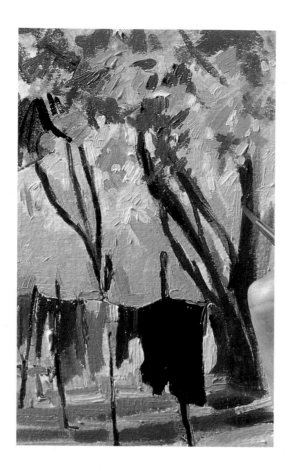

9 *Holding the brush like a knife, make swift dabs over the wet paint to suggest spots of intermitent sunshine.*

10 *Use small, flickering movements of the brush, corresponding with the flickering sun, to define the highlights on the washing line.*

11 *Make abrupt, directional strokes in pale blues, yellows, crimsons and deep greens in the sunlit and shadowed grasses in the foreground, imitating the shimmering movement of the leaves on the tree.*

12 Finally, add shadows in deep indigos and browns to the clothes on the line, the poles, grass and leaves to bring the composition together.

▼ **Colours hung up to dry, Swaziland**
CAROLINE PENNY

The viewer's attention is drawn across the stripes of shadows in the foreground to the basking, saffron sunlight in the distance. Shape plays an important part, indicating the caught moment in time: the shape of the woman in the distance indicates that she is just about to hang something on the line, and the little boy momentarily raises his arm to his head. Notice how the clothes on the line lose their identity as they taper towards the ground and are caught in the breeze and dancing light. The short, random, directional brushmarks, so visible in the foreground, accentuate the captured moment.

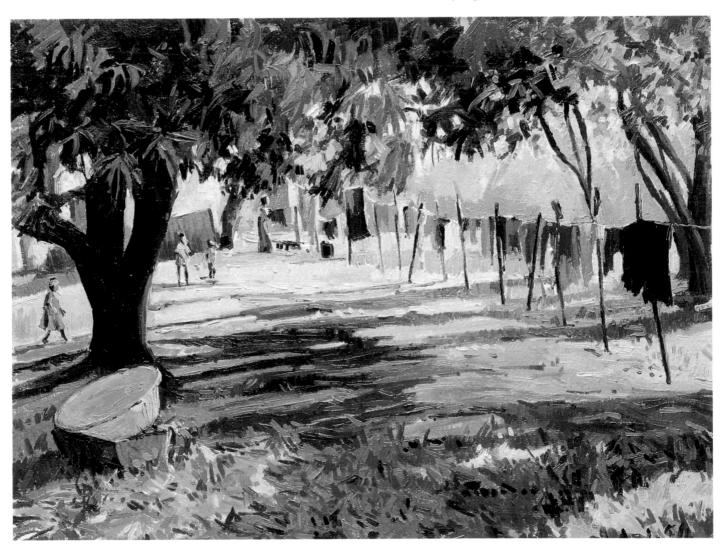

Movement &brushwork

"Brushwork" is a term for the gestural work within a picture. Experiment with different media to see how you can emphasize various aspects of your moving image through the way you apply the paint. The linear qualities of pastel, pencil and charcoal can express a simplistic immediacy of action. In contrast, oil and watercolour convey a sensuous feeling. The consistency of oil allows you to sculpt the paint. Brushwork can either freeze a picture or enliven it. But to capture the immediacy of movement, the more invigorated your brushwork, the more alive and energized your image.

▼ **Chestnut youngster Appleby**

JO TAYLOR, LINE AND WASH

While the simple, linear work describes the horse's fluid action, just enough colour wash and painted directional strokes of watercolour are used to emphasize the muscle form, giving convincing substance to the captured moment.

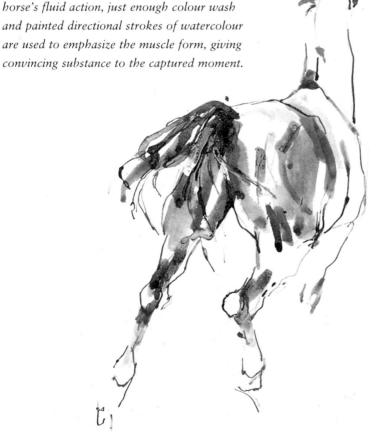

T he versatility of brushwork offers an added dimension to any picture. With linear or calligraphic strokes you can immediately translate the essence and pace of the movement into art. A predominant fluidity of line in a simple pencil sketch, for example, does much to express a sensation of movement. A more intense portrayal can be derived by adding colour. Brushwork alone, however, will never be enough to convey the substance of

The flat, grey wash lends a sense of form and weight to the horse.

While the unpainted areas leave a greater impression of the captured instant of movement, the line is just enough to indicate the form.

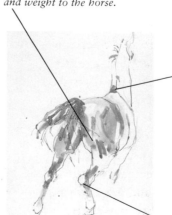

The additional strength of gestural, coloured strokes on the hock stress this point of muscle action, lending an impression of impact to the movement.

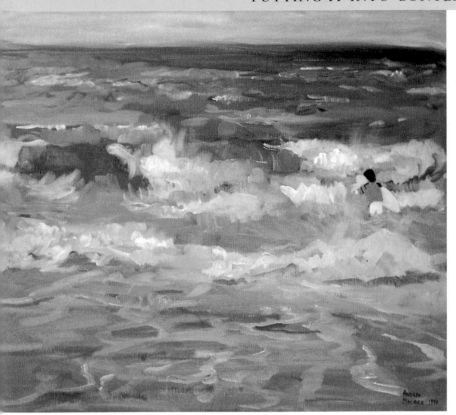

◀ ▲ **The surfer, Bournemouth**

ANDREW MACARA, OILS

Through a mixture of brushstrokes – stabbing, sweeping and directional – Andrew Macara imparts evocative, powerful movement into this seascape. The combination of different gestural brushstrokes conveys emotion and atmosphere in depicting the white surf against the dark, more flatly treated body of the wave.

your moving image. Like a piece of a puzzle, it forms a vital ingredient in the portrayal of an authentic image.

The use of brushwork

For years brushwork has been used to emphasize emotion in painting. Goya's frantic use of the palette knife in the early nineteenth century typifies this. However, it was not until the end of the century that the Impressionists exploited the maximum effectiveness of brushwork.

The innovative use of brushwork in the work of the Impressionists extended the boundaries of experimentation and progress. Although their enlightened perception was an inspiration to other artists, critics condemned Impressionism for appearing far too sketchy and unfinished. Compared to the highly polished works of their Victorian contemporaries, such radical, gesticulating brushstrokes must have shocked! However, the Impressionists were principally preoccupied with the momentary effects of moving light and shadow, and in portraying the image at a glance, they were literally painting a fleeting impression.

▶ ▼ **Still life with dried flowers**

DEBRA MANIFOLD, MIXED MEDIA

Evenly painted acrylic forms the foundation of the picture, with smudges of crumbly pastel picking out the highlights and detail. Smudged sweeps of pastel present an illusion of shimmering light.

This new look at the world encouraged a novel approach to brushwork. Claude Monet tended to reject realism in favour of colour patterns. Take a look at his famous *Impression Sunrise* (1872) which gave the movement its name. See how spectacularly his dabbing strokes transfigured the water from a solid mass into a translucent mirror full of reflections and distortions. His waterlily series almost verges on the abstract, as his zealous brushwork and colourful palette eclipse definition.

When looking at Renoir's work, notice how his brush follows the flow and folds of a dress, or waves and wisps of hair. His treatment of water, when examined, seems to consist of formless, elliptically directed strokes, but, in context, they achieve superb effects of transience and reflection.

Perhaps the greatest exponent of movement and brushwork was Van Gogh. Using thick oil impasto, he rhythmically swept his brush with tremendous vigour over what could otherwise have been a mundane composition, infusing it with vitality.

Linear work

To understand the effectiveness of line, make two- or three-minute sketches of a person or animal moving – walking, stretching, jumping etc. Look carefully for the lines the action forms: the angles of hip and shoulder, the twist of the back, and the relation of knee to ankle. You will find that time allows you to include only the lines necessary to describe the action. By keeping your eyes predominantly on your subject and interpreting the movement with linear gestures, your sketches will gain a spontaneity and liveliness. This is great discipline for training your eye to recognize the line in movement. To further your understanding of the fluidity of motion, follow the line in the air before committing it to paper.

Such gestural marks trigger a sensation of energy and vigour. Pencil, charcoal and pastel each possess a particular character, which you can exploit to achieve specific effects. Although pencil is the most obedient and compliant medium for achieving accuracy, it offers the least amount of scope for varying the character of the line between thin and thick and hard and soft through the pressure you exert as you draw. Charcoal is more flexible, since the artist can exploit the advantage of the end and the side of the charcoal stick. The end allows the artist to

▼**Lodestar**

JANN T. BASS, PASTELS

The strong, directional pastel strokes evoke the ruffled feathers of the bird, and combine with the expressive, scribbly marks to describe the bird delicately picking its way across scrubby ground. The feeling of movement is enhanced by the bird's undefined outline and indistinct legs.

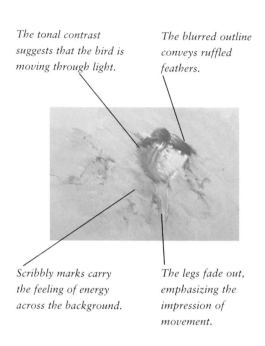

The tonal contrast suggests that the bird is moving through light.

The blurred outline conveys ruffled feathers.

Scribbly marks carry the feeling of energy across the background.

The legs fade out, emphasizing the impression of movement.

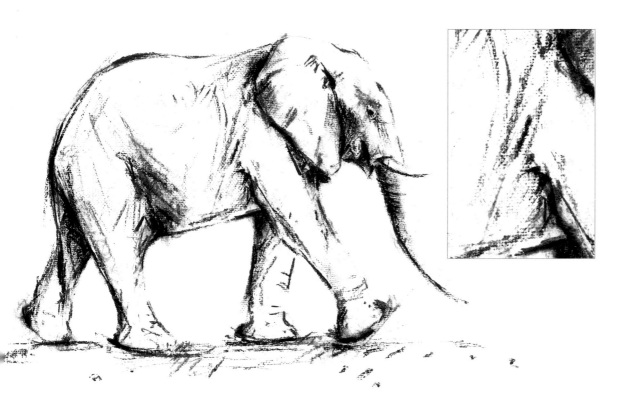

◄ Elephant

ANNABEL PLAYFAIR, CHARCOAL

Sweeping strokes with the end of the charcoal stick follow the folds of the elephant's skin as it moves. Heavier cross-hatching and smudging create convincing shadows that lend a credible impression of moving weight. The linear marks follow the line of the shoulder while still retaining the character of the skin.

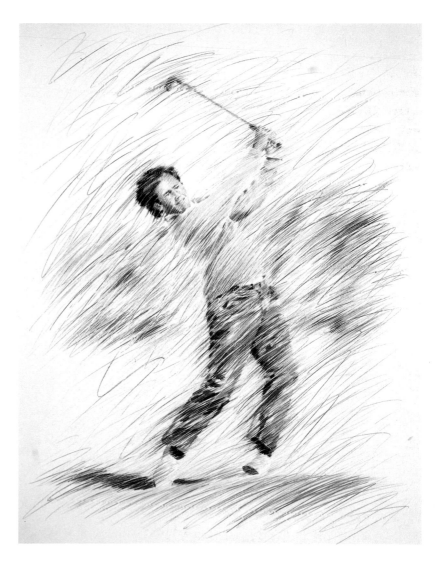

▶ ▲ Golfer

CARL MELEGARI, COLOUR PENCILS

The golfer in full swing is built up entirely with directional, linear strokes of colour that exaggerate the upward swing of the body and golf club, and impress a greater illusion of the fluid swinging action. Methodical and deliberately applied crayon strokes increase in density to suggest the form of the golfer. The image remains devoid of an outline, which would challenge the directional linear uniformity and destroy the momentum.

▼ ◄ Rounding the bend

CONSTANCE HALFORD-THOMPSON,
PASTELS

Determined, directional, linear marks suggest form and indicate the action, whilst the vaguer textural smudging implies distance and produces a powerful illusion of speed. Strong, irregular, scribbled marks detail enough of the jockey and horse's recognizable features. The horse's ears and eyes and the jockey's cap and goggles are picked out in deliberate, denser strokes. The smudged, trailing outline of the jockey and the broken colours on the horse's forehead describe rapid movement when detail is lost.

achieve a heavy dark line and establish the detail, while the side offers a sweeping broken quality to expand the detail and create an appearance of voluminous motion. Pastel not only contributes colour emphasis, but its more textural nature inspires an illusion of immediacy. Remember that it is difficult to sharpen the point of a pastel or piece of charcoal – they both crumble messily – so accurate detail will present a problem. But these media come into their own when detail is not as important as the movement you want to convey. Cultivate a vocabulary of marks – hatched strokes laid side by side, sweeping gestures made with the arm, stabbing marks made with the point of the chalk, blocking in large areas with the chalk on its side, blending one colour into another – so that you can relay the drama of the action.

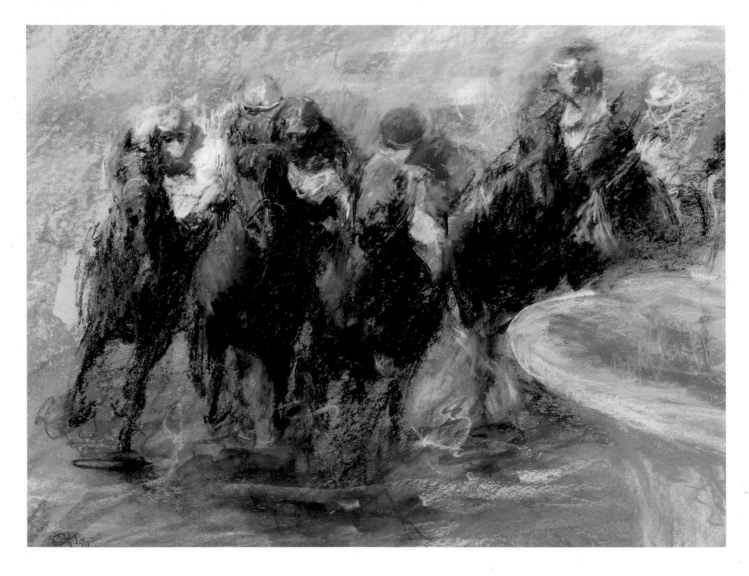

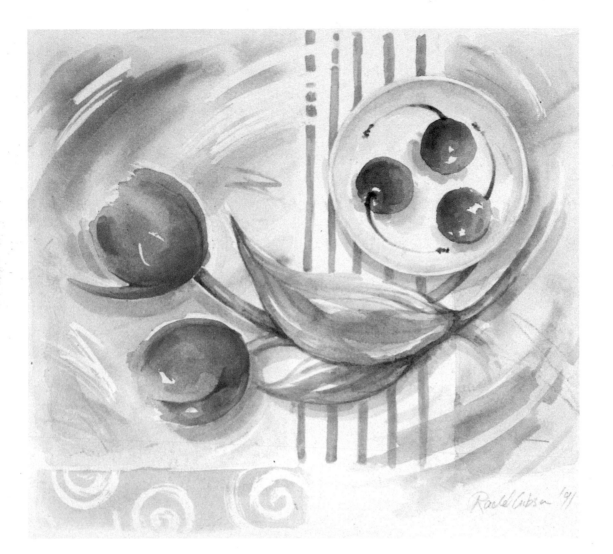

RACHEL GIBSON,
WATERCOLOURS
*All the elements are
arranged around a
circular movement,
giving the
composition a
rhythmic quality.
Each object is
described through
the circular motion
of the brush, from
the rounded cherries
and their stalks to
the sweeping stems
of the tulips. It is as
if they are all
spinning, the
cherries forming the
apex of the motion.
The contrasting,
vertical stripes on
the table-cloth
emphasize the
rotating sensation.*

Brushstrokes

By bringing in colour, the depiction of move-
ment is further accentuated. You must learn
and explore the range of techniques available
to you, and capitalize on their ability to
describe movement.

When using watercolour, the artist uses
the translucency of the paint to his
advantage by incorporating the paper into
the picture. Textured or "rough" paper
holds the paint in its grooves, allowing
wonderful open, broken sparkling effects
from a drier brush. Smoother or "hot press"
paper encourages colours to speed fluidly
over its surface, pulling back from the edge
and bleeding together to produce fascinating
combinations. "Cold press" paper reacts
similarly but with more control. Direct,
individual brushmarks over existing washes

*The fine, almost
calligraphic strokes of
the stalks relate to the
outline of the plate.*

*The highlights
emphasize the
brushmarks
themselves.*

*The directional sweep
of the brushwork on
the tulips seems to
continue into the
background.*

*The brushstrokes on
the tulip leaves
continue in the same
circular swinging
motion.*

will explain the detail of the movement you are trying to capture, while the skilful use of a drier brush dragged across the paper surface produces exciting impromptu effects.

Brushwork is far more obvious in oil painting than in watercolour, since we can clearly see the brushstrokes. Oils can be painted onto a variety of surfaces, from hardboard, cardboard and walls to paper- and linen-covered boards. Each surface affects the appearance of the oils. Canvas yields to the paint, holding it well in its texture, while primed boards allow the paint to slip about over its surface. Experiment with the different surfaces to find the one which best produces the brushwork effects most suited to your subject.

▼ ◀ Junkyard chickens

DENISE BURNS, OILS

The sunlit highlights project the darker, copper brushmarks of the chicken's feathers into prominence, while the mixture of short dabs, squiggles, curving and elliptical strokes successfully convey the form and texture of the chicken. By placing lighter colours next to dark, or using darker brushstrokes over light, the artist accentuates the movement in the feathery features. The combination of strokes with light and dark colours minimizes the detail and adds a suggestion of the ever-moving, fractured sunlight through the trees.

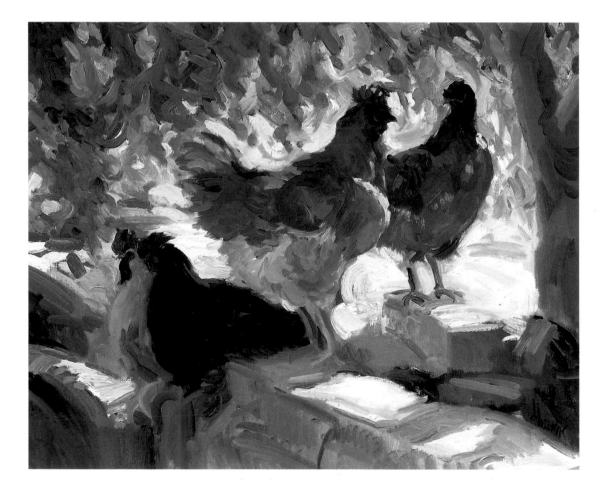

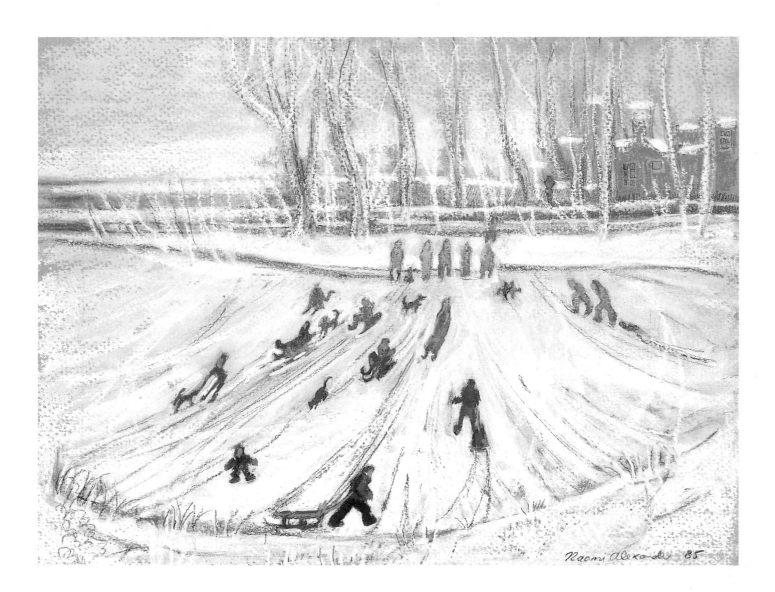

▲ Hampstead Heath

NAOMI ALEXANDER, PASTELS

This pastel illustrates the necessity for strong brushwork, as the effectiveness of the picture relies upon the linear work on the snow-covered slope. Without it, the scene would not make sense. The steepness of the slope is described by the sweeping, directional strokes in the snow, presenting the whole hill as an equilateral triangle. Flatter ground at the top and base of the slope are lightly blocked in so as not to detract from the slope itself.

The sweeping line-work converges at the top of the slope with a row of figures, which are mirrored by the trees behind.

A combination of bare paper and heavy pastel, with linear work over the top marking the toboggan tracks, conveys the angle of the hill and the downward movement of the tobogganists.

The tobogganist's action and shape follows the descending line of the slope.

EXERCISES

When observing a moving subject, it is most unlikely that you will have time to capture much detail. This, however, can be an advantage. Having to work fast will force you to focus on the essentials – the rhythmic lines of movement flowing through the form. Conveying these with minimum detail will give a sense of immediacy and speed to your drawing or painting. To keep your brushstrokes loose and fluid, work with sweeping gestures from your wrist.

▼ Essential lines

The effectiveness of lack of detail in describing the pace of movement can be seen in these three drawings, in which the definition of line and form diminishes with the increase in speed. The impression of speed and energy is conveyed through the use only of the lines that describe the monkey's extended shape in action.

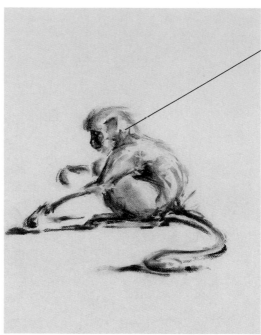

Here the movement is slow and deliberate. The monkey's action of grabbing something from the ground is described through more detailed work of the head and body, accentuating and explaining the movement.

The robust and urgent sense of speed in the running monkey relies entirely on the brevity of line and detail. The legs remain mere suggestions of form, successfully expressing the illusion of a glimpsed moment.

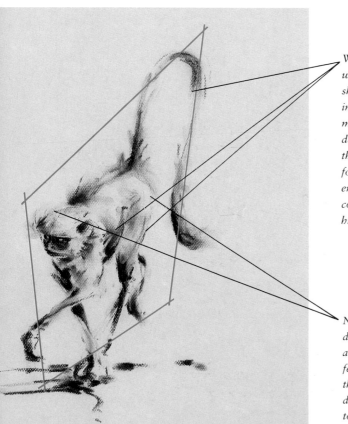

With the monkey now walking, only the shadowed areas interpret the line of movement. Strong, dense charcoal wax on the tail and stomach, fore and hind legs, emphasizes the contrasts against the highlighted areas.

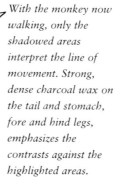

Not only does the diamond shape of the action influence the feeling of motion, but the blurred edges and definition also allow us to sense the mood and pace of the action.

The space between the fore and hind legs exaggerates the urgency of the movement and conveys the monkey's three-dimensional form. The facial expression also contributes to the image of the monkey's speed.

Varied brushstrokes

The impression of movement can be exaggerated with a variety of brushstrokes. The spontaneity and lively, translucent quality of watercolour lends itself superbly to capturing the essence of the fleeting moment. Quick, short strokes, broad areas of loosely worked wash or strong, linear sweeps of the brush can evoke the pace, character and impact of the subject. A good understanding of the horses' and riders' anatomy is vital in conveying the unusual, fluid forms to add further impact to the image.

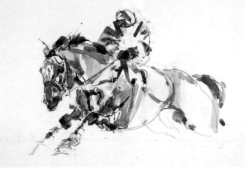

▶ *The linear pencil-work in Jo Taylor's* Viking Flagship *acts as a structural guideline that is enhanced with selected broad areas of watercolour wash.*

▲ *In Jo Taylor's* Orange Race, *the shoulder and hindquarter muscles are highlighted by loose strokes of graduated toned yellow and are juxtapositioned with dashes of browns to project them forward, alerting our attention to the tremendous power of this action.*

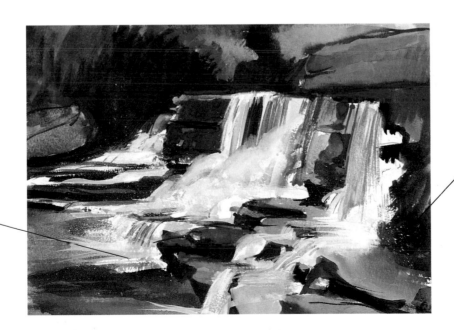

Dragged streaks of white gouache over the watercolour define the direction of the flow and describe the sparkling highlights at the top of the waterfall.

Short dabs and spots of white gouache convey the spangled spattering of the foreground spray.

▲ Blurred impression

A cascading waterfall tumbles down in a ceaseless flow of movement. The height of its fall can be conveyed atmospherically through the impact of the effervescent spray. The regularity of such repetitive motion can be conveyed through blurred detail, as details become more blurred the faster the movement.

Exploiting the medium

A still life can be enlivened and even made to appear in motion through varied brushwork. The desired effect can be derived by emphasizing the character of the medium itself, such as by using thick, impasto oil brushwork, or with a textured, broken, sweeping pastel strokes. By mixing medias, you can create a whole catalogue of original effects to enhance, exaggerate or animate your subject.

Materials used

600g/m² (300lb) smooth Waterford watercolour paper

●

Watercolour paints

●

Soft pastels

●

A selection of brushes

●

2B pencil

1 Draw a rough outline in pencil as a guide and then begin to block in the flowers and their stems boldly onto dry paper using a square-ended brush.

2 Add in darker tones in the flowers with confident, definite strokes. You can emphasize the twisting pale green stems against a darker green background to inspire a feeling of motion.

3 Pick out the flower centres with a small brush to add depth, and then concentrate on the background.

4 Mask off the straight line of the table with a piece of paper, and paint in the background with broad, swift strokes. This will provide a good contrast with the disorderly array of flowers and stems and inadvertently create a sensation of motion.

5 Next, overlay blue and green pastel on the shadowed stems, and magenta on the petals and then define the stems by accentuating their highlights with white pastel. The mixing of medias enlivens the still life.

6 Use a grey wash for the shadow areas on the tablecloth and then block in the light areas with white pastel to create strong tonal contrasts. In using pastel in this way, you can achieve a purer white against the grey-toned watercolour.

▶ **Golden Marigolds**
PIP CARPENTER
The combination of mediums, with pastel being used to invigorate the subject, brings the flowers alive and gives a surreal sensation of motion.

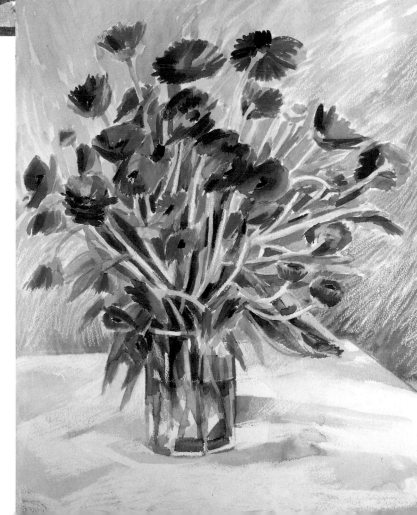

Shimmering light and colour

The multi-media effect in this project establishes a three-dimensional element in texture and form that both invigorates the image, and stimulates the action within the picture. This project demonstrates how brushwork and a combination of acrylics, collage, silk screen and fabric paints can express the dynamic and shimmering effect of a peacock catching the light as it moves.

Materials used

600g/m² (300lb) Saunders hot-pressed watercolour paper

●

Silk paints

●

Acrylic paints

●

Screen and fabric paints/jelly

●

Wax crayons

●

Oil pastel

●

Water-based pencil

●

Tissue paper

●

PVA wood glue

●

Selection of acrylic brushes

1 *Map out the outlines of the subject with a green water-based pencil, and then begin to block in the bird and surroundings with translucent silk paints and diluted acrylic.*

2 *Working from light to dark and using a small paintbrush, add the initial detailing on the peacock's feathers in stronger acrylic colour over the watery silk paints.*

3 *Next, tear up pieces of tissue paper for the flowers and areas in the background. Spread PVA onto the back of the pieces of tissue paper and attach them to the picture, smoothing them down with glue over the top as well so that they lie flat.*

4 Continue to build up the collage, squinting at the picture regularly through half-closed eyes to check that the image is still the correct shape, position and tone. Colours can be modified by patching over them with white tissue.

5 Tearing the paper gives spontaneous and unpredictable edges which enhance the vibrancy and movement within the picture. The PVA makes the tissue paper malleable until it dries, allowing you to mould it into different shapes, leaving fluid natural creases that cannot be achieved with a paintbrush.

6 Use the end of a finger to dab blobs and streaks of thick acrylic in the foliage. Without using a brush, scratch and draw into the paint to distort the fluid textural form.

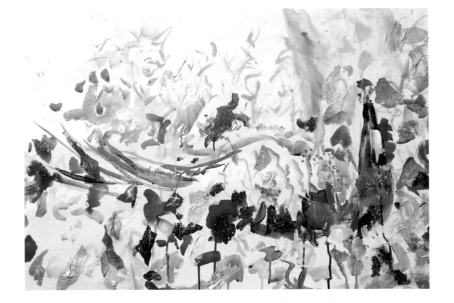

7 At this stage assess the shapes of the flowers and foliage and the form of the peacock. Paint smudgy depths in the distance, and the dense detailing in the foreground.

8 The crumpled tissue paper gives a feeling of motion. Build up colour and detail by overlaying wax crayons over the collaged tissue, silk washes and acrylic paints.

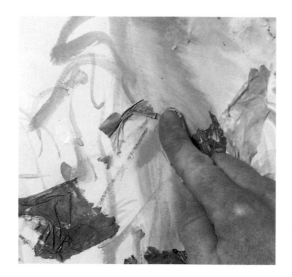

9 Work a silver oil bar densely over the collage in the background and smudge in with a finger.

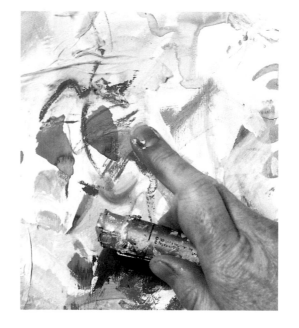

10 Returning to the peacock, define the tail feathers by dribbling liquid acrylic from a dropper, introducing an intense, vibrant streak of colour.

11 Tear a piece of coloured tissue paper and paste it down to form part of the leaves and flowers in the background. Smear PVA over it to mould it into the right shape and form.

12 *Finally, pick out the detail in the foreground with quick dashes and dabs of colour with a small paintbrush.*

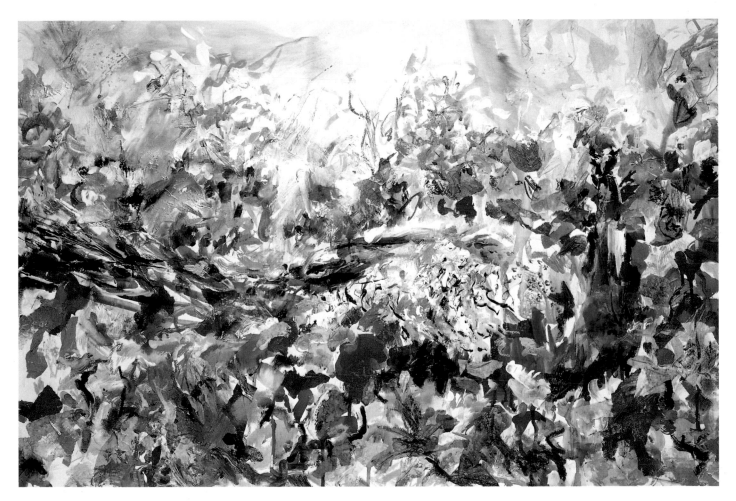

▲ **Peacock** JACQUIE TURNER

The final effect is a wonderful kaleidoscope of colour. Brushwork derived from the torn tissue shapes, smudged crayon and pastel, acrylic impasto and dribbled neat acrylic paint combine to create a highly charged, oscillating textural illusion that is atmospheric and shimmering with light.

Movement & colour

Colour qualifies your image in three ways – by the actual *hue* itself, its *tone* and the *concentration* of pigment throughout the painting. Apart from its primary role of identifying form, colour can express both distance and light, and locate an image in time and space. Some colours work harmoniously together, while others rebel dramatically. The artist manipulates these effects to create both a mood and believable context. Consider your medium and its descriptive capabilities when approaching colour. In relation to movement, your colour will emphasize, soften or blur the impact.

T he first thing to consider is the dominant colour or hue of an object, often referred to as the "local" colour; for example, a red kite or a chestnut horse. The local colour identifies the shape and form of the image. A zebra will not necessarily be recognized by shape alone, but painting the stripes will establish its identity.

◀ Hot jazz

ROSIE SAYERS, OILS
Before starting a picture, look for the overall mood of the colour and for areas of local and concentrated colour in the subject. The tone here is easily identified. The warm reds, ochres, oranges and yellows of the background tinge the whole picture, giving it a warm, exotic mood.

The red dress is intensified and propelled into the foreground through the contrast with the surrounding, concentrated areas of darker colour.

Notice how the red tone reflects off the man's waistcoat, effectively involving him in the general mood.

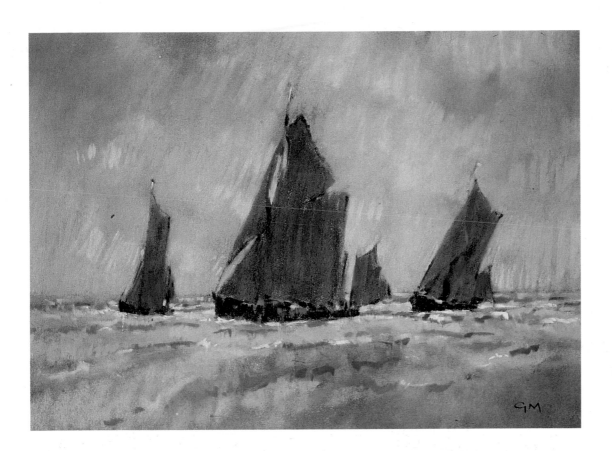

◄ **Barge race**
GEOFF MARSTERS,
PASTELS
*The tangerine-
coloured light
inspires an
atmospheric, almost
surreal mood by
corrupting the local
colour to adopt a
strange new image.
The vibrant, purple
barge sails defy
reality. The effect is
wonderfully
atmospheric as the
colours complement
and harmonize with
each other.*

The second aspect of a colour that needs to be considered is its tone, which means its lightness or darkness judged against a scale from white to black. However, the tone of any area in a painting is affected by the tones surrounding it as a light tone placed next to a dark one can make it look even darker, and a dark tone placed next to a light one can make it look even lighter. Therefore, the tones in a painting need constant comparison and adjustment. If you are working quickly from a moving subject, first establish the tonal values of the subject itself, and then pitch the tones in the rest of the picture in relation to those in the subject.

The strength and quality of light in a scene can radically alter the tones regardless of their strength under normal conditions. Imagine a dawn scene of birds alighting and taking off from a flowing river. The light would be pale and fragile, perhaps with a tinge of pink heralding a sunny day. It will resemble a delicately shaded veil, shrouding, yet enhancing, everything.

Finally, the applied colours will have a density, contributing to the strength of effect

*Purple and orange are
opposite in terms of
warmth and coolness.
This is why the purple-
hued sails protrude so
effectively from the
tangerine sky.*

*The white surf has taken on the
same brilliant purple as the
sails. This introduces a sense of
space between the sea, the
barges and the sky beyond.*

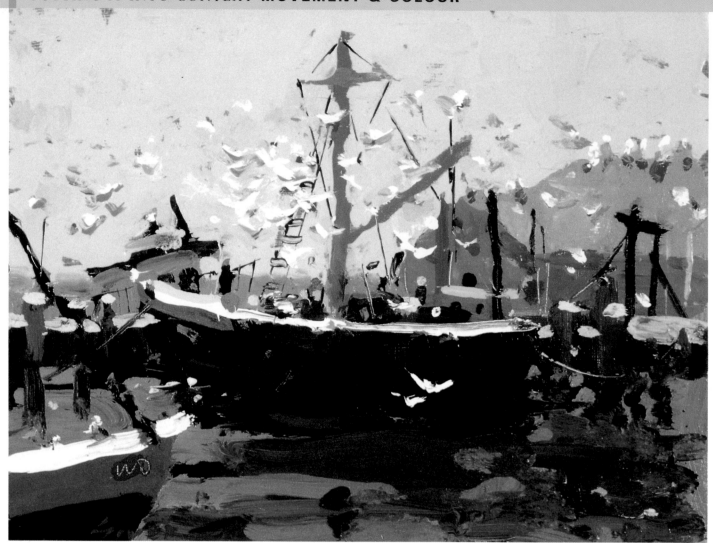

▲ Boats and gulls, Princetown

CHARLES SOVEK, OILS
Thickly applied and robust shapes of juxtaposed colour inspire mood and verve. The opposing dashes of white and grey emphasize the busy flapping of the gulls' wings, while the dark, solid shape of the hull contrasts with the irregular shapes of the undulating blue-green sea.

The warm Indian red ground lends a warmth to the whole picture.

Dashes, splodges and dabs of colour are enough to give an impression of details in the features in the distance.

A touch of cool aqua-blue dulls the white on the hull of the further boat, pushing it into the distance, while the foremost seagulls and the hull of the nearer boat are painted with a brighter white to project them forwards.

it exerts within the picture. If the artist chooses to use more concentrated colour in the darker areas, the lighter tones will contrast more strongly with them. The greater such contrasts, the greater and more dramatic the impact.

How to look at colour

When we look at the colour of a subject, we are receiving information about the "local" hue, the light direction and its effects on all the forms within the picture. The way light is portrayed will enhance, influence and adapt the "local" colour. It creates the mood and feeling of the scene, affecting its strength or weakness. So it is easy to see why colour introduces a complex dimension!

When assessing an image you wish to paint, try to look beyond the underlying colour. When you examine the coat of a

horse, for example, you will see that it is not merely a flat tone of bay, but a compilation of various colours: sepia, terracotta, ochre, umber, etc. In movement, the horse's coat will show an even greater range of tones and colours as it moves through the light.

The compound use of colour is easily understood if you study a colour photograph under a magnifying glass. Notice how the image is compiled by a toned series of tiny dots. This colourful discovery was meticulously imitated by the Impressionist, Georges Seurat. He constructed form and shape from the calculated positioning of coloured dots, which gave his work a lively, sparkling quality. If you examined a segment of one of his paintings out of context, it could seem almost hallucinatory, but when viewed as a whole, his arrangement of coloured dots produce a convincing image. It is an interesting fact that no black or white dots are included. It has long been disputed that black and white only exist as implied

▼ Dappling sun

PETER GRAHAM, OILS
By simplifying the scene into dots, dashes and shapes of unblended colour, the artist describes the sensations of cool shade and warm heat. The lemon yellow sunlight rebounds from the cool, purple-blue shadows, creating a dazzling effect. The lively treatment of colour creates a highly atmospheric impact of fractured light.

The red and yellow dabs of colour down the tree trunk describe the intensity of the filtered sunlight.

Our eye is led through the cool trees to the pale light in the distance, introducing depth and distance.

The leaves of the tree have been depicted with short strokes of straight colour – pale green, with purple shadow.

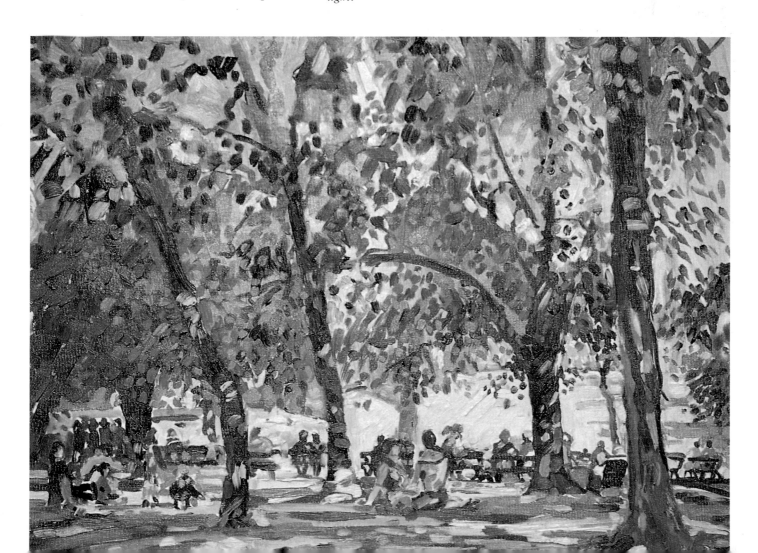

▼ **An air that kills**

David Prentice, oils

Colour expresses the menacing mood of the scene through the intense, dark, brackish hue of the mountain, accentuated by the contrasting dense, cold, cobalt sky. With the theme of this picture being mood, the artist conveys it with vibrant impact.

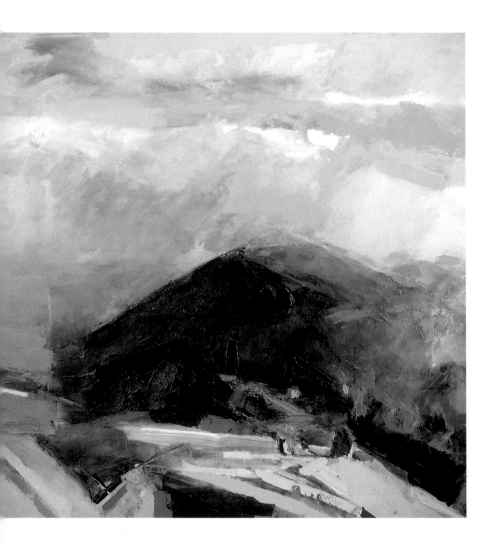

The tint of red on the mountain projects it forward, away from the cool blues, magnifying its moodiness.

The thin band of intense yellow exaggerates the darkness of the mountain behind.

colour. All blacks have a hint of blue, brown, green or red in them, while whites are affected by surrounding colours that reflect off their surfaces.

The artists of the Impressionist movement were preoccupied by colour imagery. They interpreted their subjects predominantly through highly perceived colour and tone. Particularly in the work of Monet, line became unimportant. Colour defined the shape, imbuing the picture with mood and emotion to convey his desired impression.

How to use colour

When you first look at a subject, focus on the basic colours and avoid the subtle complications of fractured and reflected colour. It is a good exercise to experiment with very few colours first, rather than swamp yourself with the decisions and choices of a large palette. Limit your colours to three or four and explore their tonal shades, density, and how they mix and relate to each other. This will allow you to develop confidence and control in handling colour, eventually producing an effective image. Use your new control to gradually add more colours to your repertoire. Next, start to look for the additional colour shapes, patterns and tones created by your subject. As with the surface colours, you will discover that depth and space can be expressed by a relatively simple palette.

The range of pure colours and the spectrum of their mixes provides a catalogue of possibilities. Subtle shades can either enhance others, or provoke contrasts with pure colour. The juxta-positioning of hues might harmonize or trigger a dramatic impact. With an understanding of how colour operates, you will soon learn the effectiveness of opposing warm and cool colours. The warmer hues – reds, ochres, yellows, oranges and umbers – when off-set against the cooler blues, greens and purples, will stimulate feelings of depth and space. How and where you place your colours will fire the mood and influence the atmosphere.

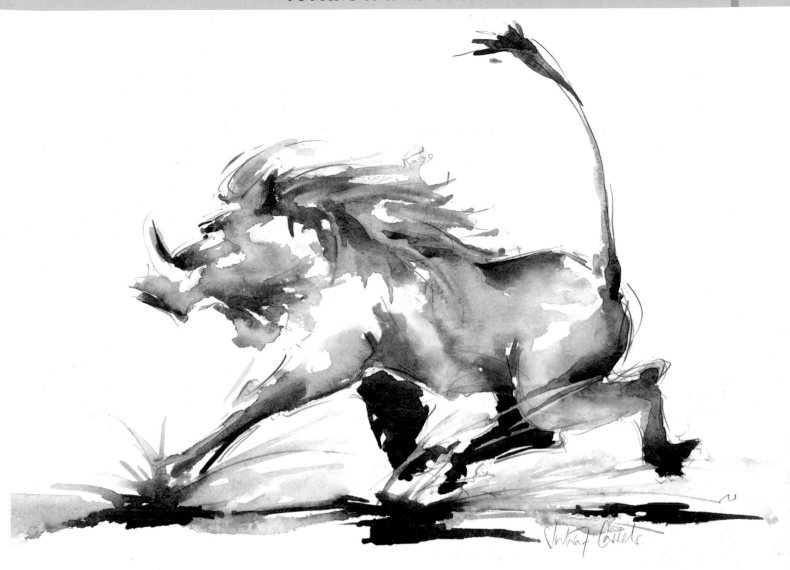

Colour and movement

Colour in a moving subject changes more dramatically than in a static one. Not only is the tone affected by the surrounding light, but the movement through the light enforces new momentary patterns and colour differences. The contrasts in something fast-moving will appear more acute and the lights and darks more intense. It often helps to "glimpse" your subject by half-squinting your eyes. This trick is particularly effective for observing moving figures, animals or birds. In this way, the fluid shapes, highlights and colour strengths are exaggerated. Effectively, you are seeing a less complicated colour image. By transferring the accentuated features, lines and colours to your canvas, paper, or board, you are able to convey a highly evocative impression.

▲ On patrol

JULIA CASSELS, WATERCOLOURS

A random pattern of ochre, sepia, alizarin crimson, orange, indian red, umbers, purple and blue captures the effects of light and rebounding colour changes on a fast-moving animal. At such high speed, the warthog's local colour is virtually obliterated by the dramatic effects of highlight and shadow. Areas of white paper combined with blended colours and shadow indicate the mood of urgency.

The shadow colour is a denser concentration of the main body colour.

If you glance at a moving animal for just a second, you will only remember a magnification of the shadows and light areas. The highlights are most effective in watercolour if left unpainted.

EXERCISES

Colour can be an important aid in helping to convey movement – some very fast-moving objects may in fact only be visible as flashes of darting or flickering colour. Allowing colours to bleed into, cut into, or overlap each other will fragment shapes, thus preventing them from looking static. This fragmented quality is particularly true of the disturbed surface of moving water. Colour can also be used to highlight points of action in a picture, and to emphasize and add drama to a scene or movement.

▶ Sketching with pastel

Colour can be highly effective in stimulating passion and atmosphere within a picture. However, it is particularly effective and vital for emphasizing movement in the subject, as it can heighten the drama around the point of impact between one element and another.

The combination of warm and cool hues over the skin and clothes enlivens the picture, and the loose, sketchy, quickly-made pastel marks evoke pace and energy.

The diagonal streaks of grass, sharpened by highlights, accentuate the direction of the moving figure.

▶ Quick brushstrokes

Colour can be used to express movement in a painting. This is easier if you observe the subject carefully while squinting at it through half-closed eyes to exaggerate the lights and darks and simplify the colours. Choosing any medium, experiment with positioning flicks, dashes, strokes and washes of colour to create an evocative impression of a subject's movement.

The "pencilled" outline continues the fluid aerodynamic flow of the bird's movement, allowing the highlights to suggest the pace of its flight. The increased detail also projects it forwards from the other birds.

Shaped dashes and almost calligraphic flicks of the brush portray the flight and movement of this cluster of birds. The lack of detail adds to the impression of movement and depth within the picture.

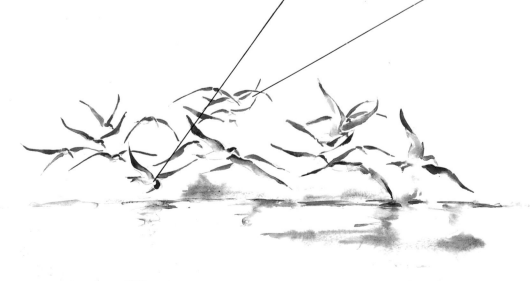

▼ Broken colour

Colour alone can express movement. In these exercises, the loosely painted shapes describe fish moving through rippling water. The water surface adds to the effect by fracturing and distorting the swimming fish and emphasizing the impression of movement.

Swirls of blue create the circular rhythm of the rippling water and eat into the yellow, white and golden fish shapes, producing bizarre fragments of colour that accentuate the motion.

Watercolour used wet into wet allows colours to bleed into each other, and the resulting intermingling shapes suggest the fish moving through water. This layer of washes is left until it is semi-dry, and then strong-coloured shadows are painted on the fish and water ripples, which creates the dancing, sparkling effect of light playing on the abstracted shapes of the fish.

Changing colours

By varying and juxtaposing colours, you can imply movement and also describe, locate and inspire atmosphere. This Mediterranean scene is painted with two quite different groups of colours, creating two entirely different impressions of the same scene.

▶ Muted colours and gentle contrasts create a quiet, still, but nevertheless characteristically Mediterranean ambience, the warm haze enveloping the houses, tumbling bougainvillaea and even the grey shadows. Although this picture lacks the initial impact of the accompanying one, the subtle tones suffuse it with a gentle charm.

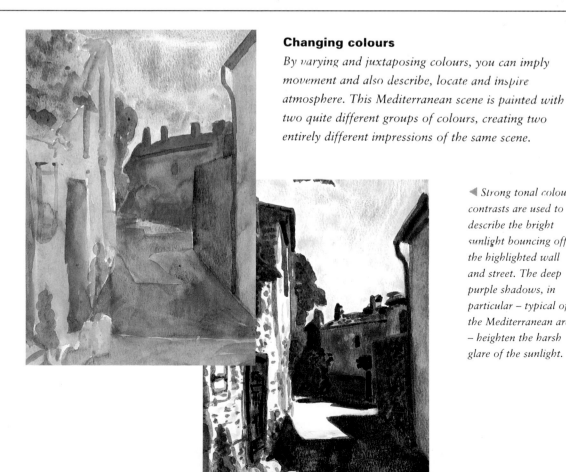

◀ Strong tonal colour contrasts are used to describe the bright sunlight bouncing off the highlighted wall and street. The deep purple shadows, in particular – typical of the Mediterranean area – heighten the harsh glare of the sunlight.

Fast and loose

Where haste is the theme of a painting, colour can take over and dominate the drawing to convey a vibrant, evocative impression of speed. By applying strong, robust lines of colour in the foreground and allowing them to fade, bleed and blur into the background, you can describe both depth and distance, combined with a powerful sense of pace.

The composition is based on pencil sketches. The angles of heads, legs and hooves indicate the horses' pace, and the shading suggests the direction of the light.

Materials used

180g/m² (90lb) Saunders rough watercolour paper

•

Watercolour paints

•

Very fine sable brushes

•

Chinese water brushes

•

2B pencil

1 *Sketch in the outlines of the subject in pencil as a guide. Then dampen the paper all over with a sponge and, working wet into wet, lay an initial green wash; then lay an ochre and grey wash for the foreground horses.*

2 *Soak up excess water with a sponge, and then lay in the initial colours of the horses and jockeys with pale washes. Leave the painting for 30 minutes, by which time it will be partially dry. Then add more detail to the horses using a Chinese brush. (Chinese brushes hold a lot more water and form a good fine point at the tip.) Add finer detail with a very small sable brush.*

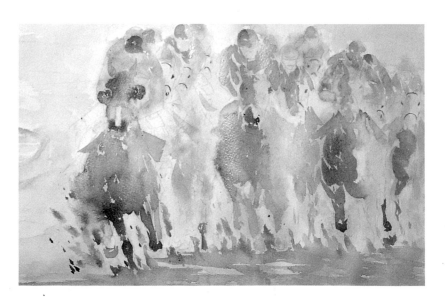

3 *Add another layer of colour over the semi-dry paint on the horses and jockeys, which will make the colours denser and richer. Do not exceed two washes at this stage or the colours will become muddy. With stronger colours and features in the foreground the image begins to materialize and gain a sense of depth.*

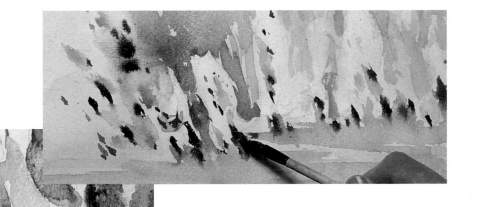

4 Add deep sepia to the clods of kicked-up earth, and allow them to bleed to emphasize the pace of movement.

5 Add a purple shadow wash to the jockey's cap and visor, which will make it more three-dimensional and give a sensation of movement through light.

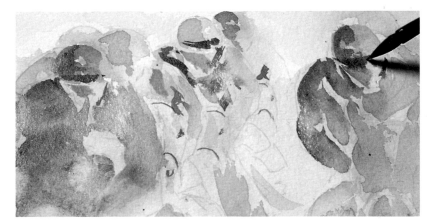

6 Put in the finer details, such as the whip, with a small brush, and dab in the spatterings of flying earth.

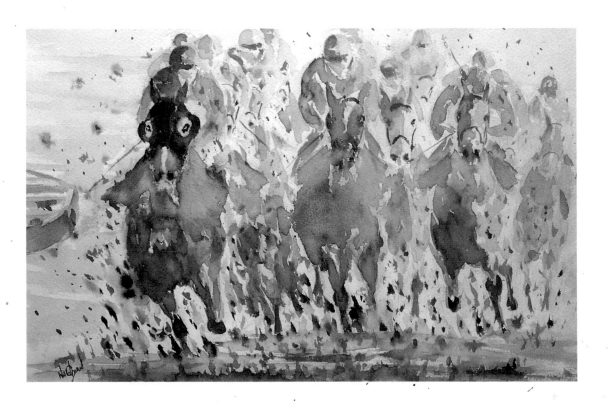

◀ **Mudlark**
GLEN WAWMAN
The impact of speed is overwhelming. The watery washes of loose, bleeding colour have completely obliterated the drawing, leaving an illusion of moving colour. At the same time, just enough detail on the jockeys and horses is included to support the impression of their fast approach.

Movement & composition

Composing a picture is about decisions. You must decide where to locate your focal point, which elements to include, the correct proportion, perspective and balance. With a moving subject, consider what angle, perspective and position will provoke the greatest impression of action. You may opt for a foreshortened view, coming towards you, or one diminished and going away. Even a three-quarter view might emphasize the character and pace. Always remember to allow a space for your subject to move into as this will suggest the anticipated direction of movement.

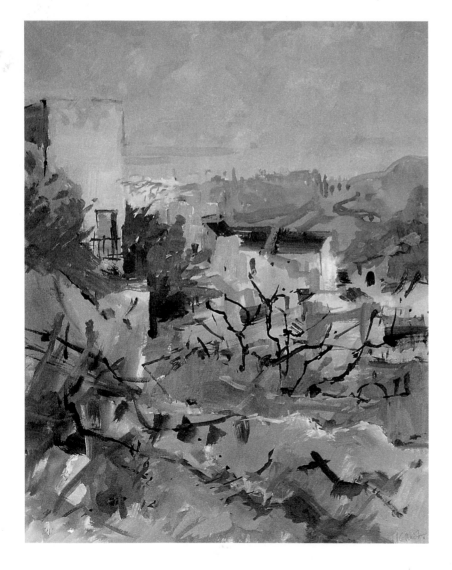

◀ ▲ **Frigiliana from the mule path**
JOAN ELLIOTT BATES, GOUACHE
The very definite tonal layers paling towards the horizon convey the sensation of space and distance. The angles of perspective and the proportions of the buildings emphasize this space by leading our eye into the far distance. The diagonal shapes of increasingly paler and bluer tones draw the eye into the distance.

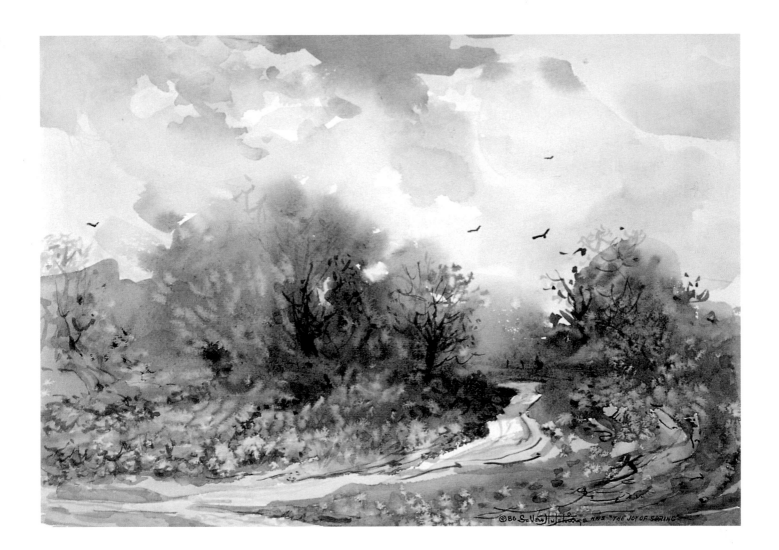

© 86 LaVere Hutchings KWS "THE JOY OF SPRING"

There are many things to consider when composing a picture. Once you have established its size and shape, you can arrange the layout by answering several key questions: where should the edge be? Do the various elements balance? What should the focal point be, and how should the eye be led around the picture to it? You will find that the answers to these questions fall naturally into place as your picture develops, but their order will depend upon the subject. Each element is a necessary and integral part of any picture. Working together they fulfil the aim of the artist by creating the desired impression.

Size and shape

Conventional pictures are rectangular; standard paper sizes and canvases come in this shape. It is more convenient and often

▲ ▼ Joy of spring

LaVere Hutchings, oils

The impact of this composition relies on the dramatic and contrasting colours in the sweeping road, where acid yellow and white are made more prominent by the cool, dense blues of the shadowed trees. The cloud formations, flight of birds and rotund trees exaggerate the curving direction. The road leads the eye from the pale foreground into a deeply shadowed distance that forms the focal point, and beyond.

▼ Head on

JONATHAN TROWELL, PASTELS

A fantastic illusion of speed is created by varying the relative sizes of the different horses, the centrally positioned, leading horse being the largest, and the others reducing in size and focus towards the back. The stronger tones also accentuate the leader and pull him forward in the scene. The arrangement creates a sense of depth and distance and emphasizes the forward action.

easier to work within this framework and to use the whole surface area to organize the elements of your picture. However, there is no hard and fast rule regarding picture shape. The rectangular paper or canvas can be used in an upright – or "portrait" – format, or used lengthways as a "landscape". Sometimes the artist achieves a greater sense of impact by placing a landscape within a "portrait" framework, and a portrait within a "landscape" one. Square, oval or circular pictures can be just as emphatic when used with a compatible subject. Vignettes that do not fill the frame can be highly evocative.

With a moving subject, it is simpler not to have any preconceived ideas about the shape. Once you have established the best angle at which to portray your moving image, let the other elements grow around it in such a way that they emphasize the impression of movement.

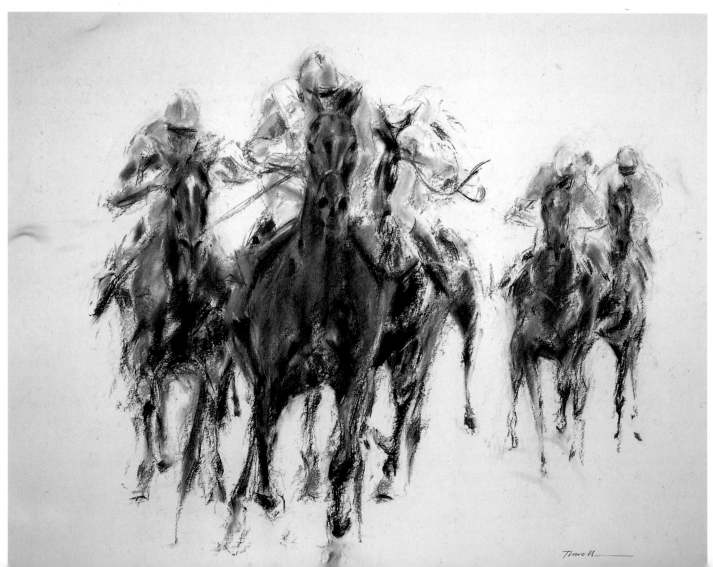

◀ ▼ Silent friends
JOAN ROCHE, WATERCOLOURS
This unusual position, looking down on the fish, allows shape and directional movement to dictate the composition. The angles of the overlapping fish, fractured by the reflections, create a composition of strong directional lines and colour patterns. The cropped fish shapes emphasize the angle and diagonal direction of movement.

Some artists prefer to decide where to position the frame once the picture is fully completed. By positioning a mount carefully, the artist can achieve the most effective impact from the picture.

Think about the size of your paper or canvas in relation to the scale of your picture before you start. A small landscape shape may be extremely effective, but if you want to gain a fuller feeling of space, choose a larger surface area. Alternatively, depicting small subjects on too large a piece of paper might cause them to look a little lost. But increasing their size to fit, however, could appear a bit odd, out of proportion and unrecognizable in scale. You would then incur problems of synonymously re-scaling the other elements, and achieving their correct proportions and spacial relationships.

Where to put the edge

Putting an edge around your picture can influence it immensely. Editing or cropping your work can imply a strong immediacy by drawing your eye more urgently towards the centre of interest. Imagine the scene of a woman having dropped all her market shop-ping in the middle of a bustling, crowded street. By cropping some of the people or market stalls, the artist might utilize an arm, head, awning or fruit basket to direct your eye dramatically towards the woman. This unconventional "edging" was originally inspired by the "snapshot" effect of photography. By adopting this new reality, the Impressionists proved that it was not necessary to include every figure or object to convey their desired illusion. They found that editing created a more interesting and dynamic sensation of exaggerating the colour shapes and spaces.

When you do not know where or with what to position your edge, you will find the use of a "view-finder" helpful. You can

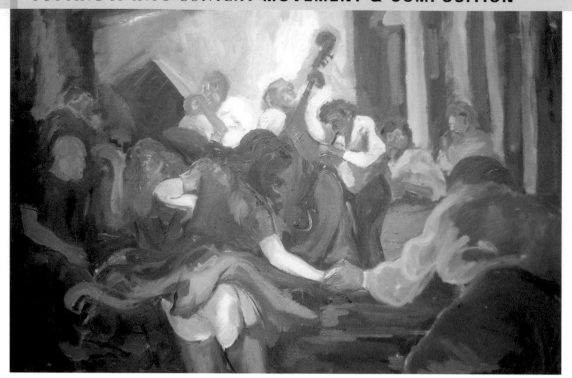

◄ ▼ **Saturday night at the 100 Club**

ROSIE SAYERS, OILS
Our attention is drawn directly to the central characters because the figures that surround them are cropped. The pink of the girl's swirling skirt describes the rhythm of the music and the eye is led in a sensuous backwards "C" through the arms of the dancers to the top of the double bass.

▶ ▲ **March of the mouldy figs**

ROSIE SAYERS, OILS
By heavily cropping the figures, the artist has brought us closer to the action, so that we almost become embroiled in its energetic atmosphere. Even the instruments of the players have been cropped, placing us as one of the "marchers" and not merely a spectator.

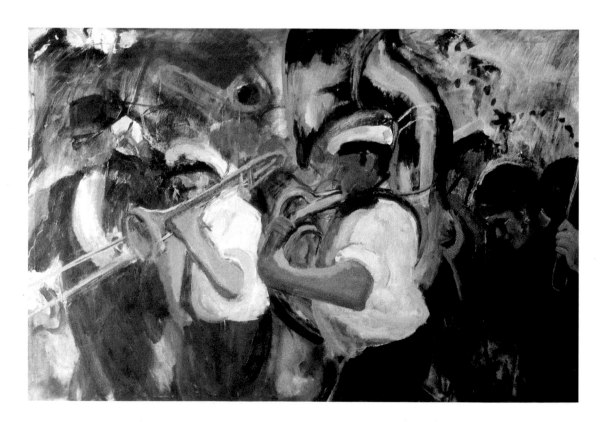

make one simply by cutting a rectangle out of a piece of card. By holding it up at arm's length to your scene, and twisting it either vertically or horizontally, you can instantly see where and how to place your image to attain the greatest impact. With landscapes or seascapes this is particularly useful as the panorama is so vast.

Placing the frame around your moving subject is vitally important for stressing the impact of that motion. By placing the subject slightly off-centre, the artist draws the viewer's eye into the picture and into the mood and feeling of motion. Often this trick will enhance the direction and pace of the action. If your subject is placed centrally within the frame, the viewer's eye is not stimulated. The image may make a statement of the action, but it will be devoid of all sense of pace or movement across the page. Positioning your subject in a corner or at a side introduces new and interesting angles and perspectives that leaves an expectant space for your subject to move into. This maintains a feeling of fluidity, momentum and rhythm.

Balance

Balance is also essential in a composition. Without any balance your picture would seem lop-sided, awkward and unrelaxing to look at. Balance and counter-balance is about weight. Imagine using a pair of old-fashioned kitchen scales to create this visual symmetry; the artist uses shape, colour and size to achieve his balance within the picture. Light areas are counter-balanced with the darks. A tree in the right of the picture can be off-set by a cloud in the left. Shapes interact allowing their asymmetrical proportions and spatial distances to balance and make sense. Opposing colours play off each other: cool against warm, intense against pale. Strong colour applied randomly here or

▶ ▼ In Dublin's fair city
HAZEL SOAN,
GOUACHE
The compositional device of strong diagonal lines converging at a central point in the distance is obvious here. However, the artist dramatically exaggerates the radiating shadows over the cool sun-bleached ground and the perspective diagonals of the buildings with undeniable impact. The dark, upright, back-shapes of the people mirror the upright shadows of the buildings, and their diminishing size indicates the distance.

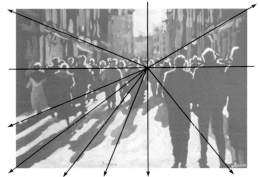

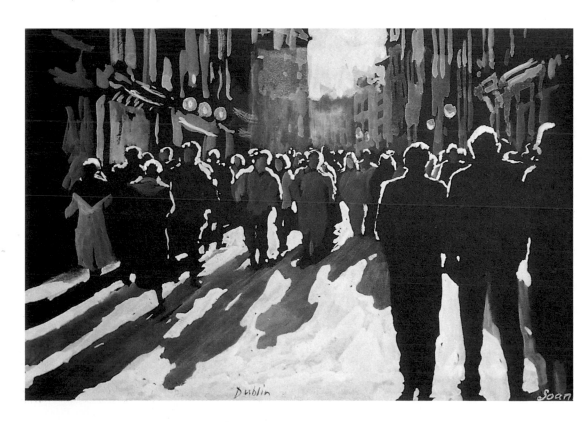

there will alter the emotive impressions obtained by existing colour. For example, a small red bucket in the right-hand foreground of a beachscape will automatically lure your attention away from the expanse of pale beach. Balanced by a red beach umbrella on the left, nearer the water's edge, the eye will be diverted and dragged directionally across the sand towards it. Try to see balance as a juggling act using the elements of shape, colour, weight and proportion.

Leading the eye

A picture needs a focal point to entice and draw your attention. An image involving movement uses the focal point to contain the pace and force of the drama. Painting a picture which lacks a core of interest results in an unsatisfied, empty feeling as your eyes roam vaguely over it, with nothing to pinpoint your attention. Abstract paintings are often devoid of a focal point, but in their place colour, shape and patterning reign.

We have already established that composition is about decisions. It is at this point that you must decide what and where the emphasis must be. Is it in the eyes of a running man, the foreleg of a galloping horse or a windblown tree on the horizon?

Artists employ several tricks to accentuate the focal point. They may construct

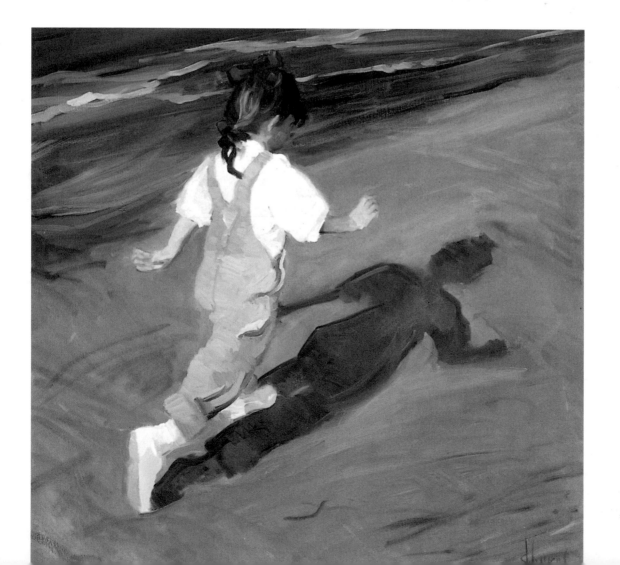

◀ ▼ **Shadow chase**

DENISE BURNS, OILS
The foreshortened shape of the running girl and her shadow form distinctive diagonal lines of directional movement. Her near foot draws us into the picture, and also forms the base point of the directional lines, from which the power and energy explode. The artist allows the shoreline and the swing of the arms to mirror the girl's fluid action. The diagonal lines of movement create a triangular composition with the force of impact radiating from its base point.

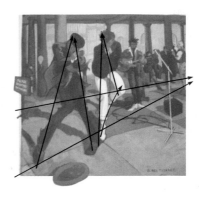

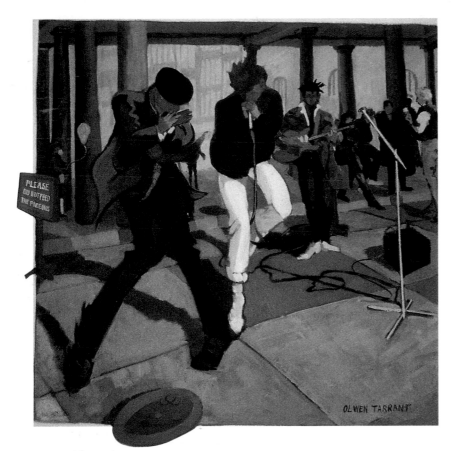

◀ ▲ **Street music**

OLWEN TARRANT, OILS

The artist has deliberately broken the frame of the picture to derive greater impetus. The orange hat lures us towards the bizarre and over-exaggerated foreshortened postures of the musicians. The diagonal lines of the flag-stones and roof lend a sense of depth as they converge towards the distance.

arrangements of shape and tone, but most effectively, they use colour contrasts. Lighter areas stimulate the eyes causing the pupils to expand, while the darker areas have the reverse effect. By setting lights next to darks, you can produce a visual "see-saw" sensation, which grabs the attention and retains the interest.

Panoramic views of landscapes or sea-scapes are so vast, one's attention is pulled in several different directions. Such wide views tend not to have one particular centre of interest, so it is up to you to create one. This may mean increasing or reducing the size of one object so that it does not fight or distract attention from another. Two sheep of equal size grazing side by side in a field would compete for attention but, by portraying one larger than the other, it creates a focal point. Including more than one core of interest confuses and distracts the viewer, and only succeeds in dissolving the impact.

Having established the focal point, the artist aims to guide your eye to it. By leading your eye through and round the picture, you can feel the atmosphere and make sense of the image. The linear direction of a road or fence, the meanderings of a river, can lure your attention from the foreground to the apex of the drama. An open door, gate or window will invite you to look through it. But remember that overdoing such clichéd features may result in your picture being inconceivably corny!

A darker area in the foreground will encourage the eye to seek out the lighter ones on the horizon. An interruption to your guided tour, like an open gate along a road, might persuade you to stop and explore the rest of the picture before continuing to the focal point.

Colour contrasts and lively brushwork create lively areas that draw the eye, so should be used around the centre of interest. Light patterns on the ground, ripples on the water's surface, and fur and feathers, can be used to lead the eye through the picture.

EXERCISES

Clever composition can actively increase the sense of movement you are trying to convey. The trick is to compose your piece so that you lead the eye in the direction of the movement. If a subject is moving away from the viewer and into the background, emphasize the three-dimensional depth of the scene so that the eye is literally drawn into the picture as if into a stage set. Use any diagonals to underline this effect. Think, too, about where to crop your picture for maximum effect.

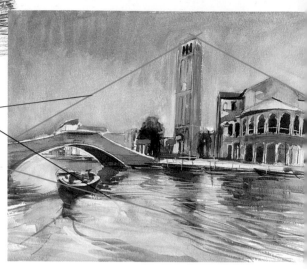

Compare the position of the tower here with the finished painting. By shifting it slightly off-centre, the viewer's eye is enticed towards the focal point by drawing it through and across the picture.

The buildings and their reflections produce a chevron shape that drags the eye from left to right, while the up-lifting angle of the bridge to the church tower increases the impact and strengthens the composition.

▲ Using perspective

Traditionally, the focal point lies at the apex of the converging diagonals. In this Venetian scene, the arching bridge and rotunda building with colonnades come together at the tower of the church of Santa Maria del Annafo. The lines of the buildings and the general directional brushwork in the ripples on the water unite to emphasize the focal point.

▼ Framing your composition

When composing a picture that includes movement, it is important to allow a space for the subject to move into. The greater the space, the greater the implied or anticipated sense of speed. By framing the subject in different ways, it is possible to see which composition creates the most effective impression of the sheep moving across the field of view.

If the sheep is placed centrally, it is suspended in a static, freeze-framed pose.

If the frame is moved down and to the left, the sheep floats in mid-air with no space to run into.

If the sheep is placed lower in the frame on the left-hand side, a large area of ground is left vacant for the sheep to run into. This is the most effective composition. It suggests and emphasizes the pace of movement as the viewer's eye is directed into the anticipated space.

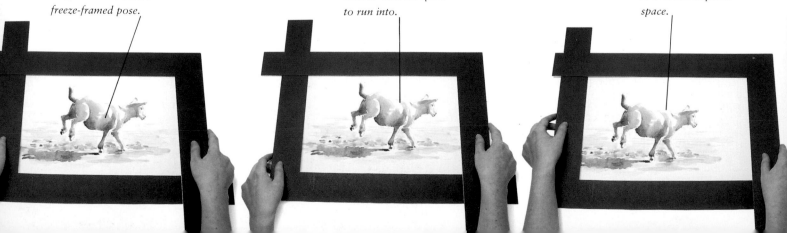

1 Use firm, linear strokes to mark the initial shapes of the figures within the composition, and block in the darker hues and stronger colours.

◀▼ Creating depth

Balance and depth are important aspects of composition. The two old ladies counterbalance each other through the angle of their gait and the robust contrasting colours of their clothes. Their relative sizes, the further figure being considerably smaller, lead the viewer into the image with a strong sense of depth. The broad, sweeping brushstrokes emphasize the rolling walking movement, influenced by the weight of the bags, while the use of dense colour offers depth and balance.

2 *The placing of the lightly sketched figures creates a sense of distance together with an illusion of the rocking walking gait of the old ladies.*

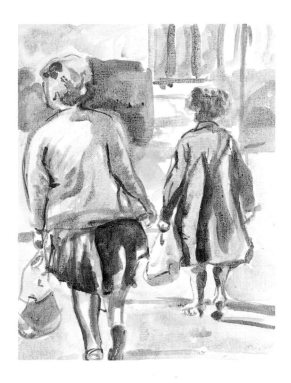

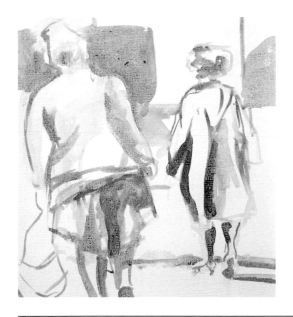

3 Build up layers of washes on the farther figure to add weight in the strong, shadowed shapes on the back of her coat.

4 *Block in the shadow areas on the ground and in the background.*

◀ Moving forward

The angle of the white railings leads into the picture, and the leading horse inclines towards the rails to give a greater impact to the sensation of speed. The composition of Constance Halford-Thompson's Fast finish *relies on this forceful pull across the canvas.*

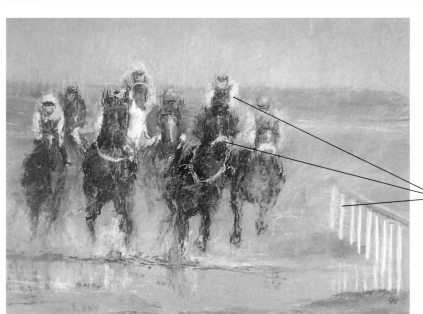

The white of the silks and nosebands counterbalances the white of the rails.

Following the action

The aims of this project are to examine the changing shape of a human figure at different stages in a sequence of movements, and to use those shapes to create a working composition. It is quite a challenge to portray movement in the figure with anatomical accuracy, so try to look for shapes and lines of balance in the action.

Although the dancer is stationary, movement can be anticipated through the tilt of her head and the poise with which she holds her arms, hands and fingers.

Materials used

Pastel paper

●

Soft pastels

1 *Using black pastel, draw the shape of the dancer with long, quick, sweeping strokes, starting at the head. Notice how successfully the broad, concave line from the poised elbow, through the torso, down towards the outward kick of the skirt portrays expectant movement.*

2 *Smudge the black pastel on the dancer's leg with a finger to create dense colour and lend a sense of volume. Describe the folds of the skirt with firm, linear, gestural strokes that balance those used to describe the hair, fingers and torso outline. Lightly suggest the upper body form with blue pastel, which adds interest to the monochrome drawing.*

3 With the first figure more firmly etched in by smudging the black pastel with a finger and depicting the torso in blue, quickly outline the shape of the second movement. It is important to keep the heads aligned in a moving sequence. Already, as the dancer begins to twist away, the arms are extended into a T shape from the initial shape; this is emphasized by the strong diagonal of the outstretched leg.

4 Using the side of the black pastel, make firm downward strokes to indicate the direction of the third movement. The left leg swings forward as the torso twists away. The position of the arms counterbalance the legs.

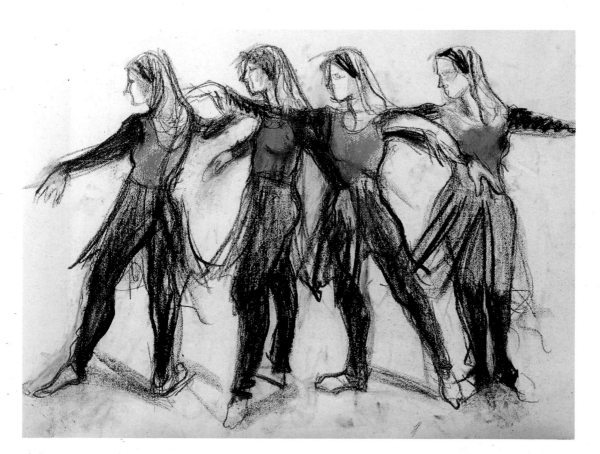

◄ **The dancer**
SHARON FINMARK
This sensitive composition interprets the dancer's movements in line and shape, the opposing, outstretched legs and their corresponding shadows counterbalancing each other, as does the willowy sweep of the arms and hands.

Leading the eye

The compositional values of a landscape painting lie in the sense of depth, tonal balance and placing of the focal point, and most importantly in how the eye is led through the picture. Gradations of tone towards the horizon help to describe receding space, and the winding road leads the eye towards the horizon.

The road and trees link up to form an S-shaped route snaking through the landscape, leading the eye to the focal point at the house, and beyond to the horizon.

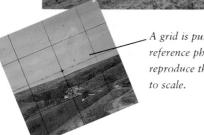

A grid is put over the reference photograph to reproduce the image to scale.

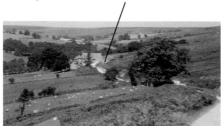

Materials used

Acid-free card

●

Gouache paints

●

Sable and bristle brushes

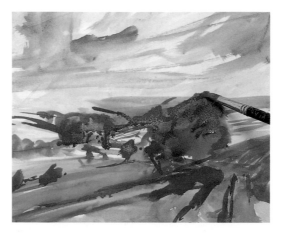

1 *Gouache dries very quickly, so sketch in the undertones of the sky, hills and trees rapidly in stridently rich, warm colours. This forms a good base on which to build up the greens.*

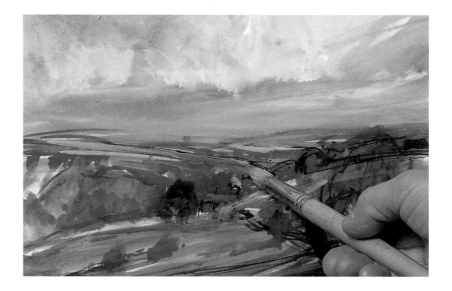

2 *Working over the red foundations, scrub in blues and greys loosely over the saffron sky, and introduce a cool blue/green to form the distant hills. This immediately creates a sense of depth in the landscape.*

3 *Add warm sap greens in the near ground to give a realistic appearance of the green hills. Put in the shape of the roof (the focal point of the finished painting) with a small brush.*

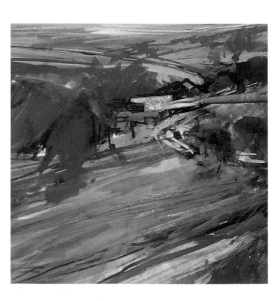

4 With the white house and pale road painted in, you can concentrate on the finer details. Using the end of a paintbrush, scrape in the edge of the near field, revealing the pale, warm tones of the original foundation colours.

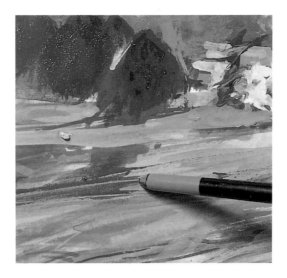

5 Use stripes of pale lemon yellow to form the highlighted areas of near ground. Then select a small brush and create the impression of the foreground scrub with closely crosshatched lines of blue, orange and yellow.

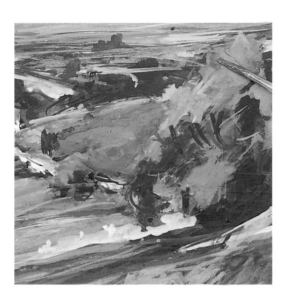

6 Indicate suggestions of the sheep in the field. Finally, use directional brushstrokes in the large tree to add a sense of weight and form and to unite the greens of the foreground with those in the distance.

▶ **Castleton, North Yorkshire**

DAVID CARR

A strong composition has been created through determined brushwork and a structural use of colour. All the elements in the foreground converge on the road, which in turn leads the viewer to the house and on, irresistably, to the horizon.

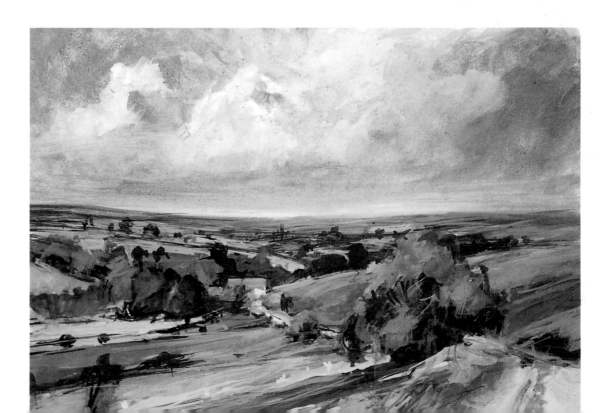

SECTION

2

Putting it into practice

This part of the book deals with putting what you have understood from the first part into practice. Whatever the subject matter of a painting, it can be interpreted through shape, brushwork, colour and composition. This section concentrates on how you can use these four elements, individually or in combination, to interpret figures, wildlife, landscapes, seascapes and objects in motion.

▶ Clockwise from top left:
Fishing fleet (detail) *Hazel Soan*, **Two from home (detail)** *Jonathan Trowell*, **Summer fun** *Denise Burns*, **Along the Thames at Richmond I 1992 (detail)** *Jacquie Turner*

Movement & figures

By introducing movement to figures, you are effectively bringing them alive. The human figure is supple, flexible and rhythmical in movement, full of fluid shapes and evocative lines. An understanding of anatomy is an obvious advantage, as the artist can portray convincing muscle movements, position and balance. Facial expressions, too, become animated in movement, and relay the power, pace and mood of the action. Look beyond the overall figure to factors such as balance, angles and lack of definition that contribute so importantly to conveying the illusion of movement.

The human figure has always been a dominant theme in painting. Artists over generations have depicted the human form, initially as a mark of honour or respect for their benefactors and patrons, such as members of the church or Royalty. Among the works of artists in Constantinople in the early twelfth century, and of Fra Angelico three centuries later, are beautifully executed icons of the Virgin Mary, though they are static and two-dimensional despite their superb, intricate detail. Even Holbein, the finest portrait artist of his day, portrays his *Henry VIII* (1542) with the recently acquired knowledge of form – resulting in a wonderful but flat depiction of the infamous monarch.

◀ **Girl and ball**
RAY MUTIMER, PENCIL
The rounded forms of the human body contain no angular or straight lines. Here, a fluid line forms the concave arc of the back down to the supporting knee. Denser linear work on the back of the knee and supporting leg lends credibility to the transfer of weight as the girl moves.

► **Autumn sunshine**

LaVere Hutchings, WATERCOLOURS

Colour is used to portray the pace and mood of the figures as they move through the autumn sunshine. The boy's raised hip, the deeper, intense blue of the mother's supporting leg, and solid shadows imitating their actions, accentuate the image.

▼ **Market scene**

Tom Coates, OILS

The energetic, thick oily brushwork characterizes the business and bustle of the market, while the kaleidoscope of colours and their highlights describe the chaotic atmosphere. The loose treatment of the subject suggests just enough for us to identify the preoccupied figures.

▶ **In search of water**

JULIA CASSELS,
WATERCOLOURS
*Rebounding darks
and lights are used
to describe the
rhythmic movement
of the figures. The
back-swinging arm
and bucket thrust
the hip forward into
the bleached light.*

Michelangelo, at the turn of the sixteenth century, was a sensational inspiration to the art world. Perhaps the finest draughtsman of the human form, artists today still look to him for inspiration. His figures are imbued with solid volume, muscle and energy as they twist and turn with supple fluidity on the ceiling of the Sistine Chapel (1508–12). His understanding of human anatomy was so acute that he could manipulate his human figures into any position, adding a new depth with the introduction of foreshortening. But despite such innovative work, his figures still remain frozen in action.

Even two centuries later, the essence of movement still remained an unknown quantity. Gainsborough and Watteau had perfected the skill of setting their subjects

into verdant landscapes and evoking a mood of harmony, but there was no suggestion of movement. Delacroix's *Liberty Leading the People* (1830) imparts verve, drama and impact to its patriotic content. However, all areas of the canvas are rendered in sharp focus, which "freezes" the action.

The advent of photography heralded a better understanding of movement. For the first time, it allowed artists to study the anatomy of human action, especially fast action. This was particularly beneficial in the case of animals and birds, who never make easy or compliant models! Now artists were able to concentrate on capturing the impression of movement. By abandoning, abbreviating or selecting the details necessary to express the action, artists could achieve a far greater impact of movement.

Characteristics

Recognizing the characteristics of your moving figures is a matter of learning how to look. You need to see beyond the purely visual shape of the human body for specifically animate features. Notice how the hair swings when the head twists round, or bounces while running. Watch the expression of the eyes and tension of the mouth during fast movement. See how your eyes move up when pulling a hat on, or your eyebrows furrow when lifting something heavy. Facial expressions can be learnt by giving yourself different actions or tasks to perform in front of a mirror – or by asking a friend, so you can sketch them quickly.

"People-watching" is invaluable. Quick one- or two-minute sketches help enormously to record the gist of an action. Even minimal gestures with a pencil will open your mind to the fluidity of the human form. Make visual notes of how people stride, waddle, roll or shuffle when they walk, depending on their height, weight or size. Old people tend to stoop and walk bow-legged, whereas a child will have a large head tilted up, a concave back, pouting tummy and pert bottom. Note how the balance and the alignment of body parts change in relation to each other while

in motion. Remember that each person will perform a similar action in a different way; these idiosyncrasies unite to make what we call character or personality.

Expression

As mentioned earlier, it is our very familiarity with the human figure that makes it difficult to see with a fresh eye. Familiar too are the facial expressions associated with particular actions. From them we can read levels of strain, exertion and force corresponding to movement. Facial expressions which conflict

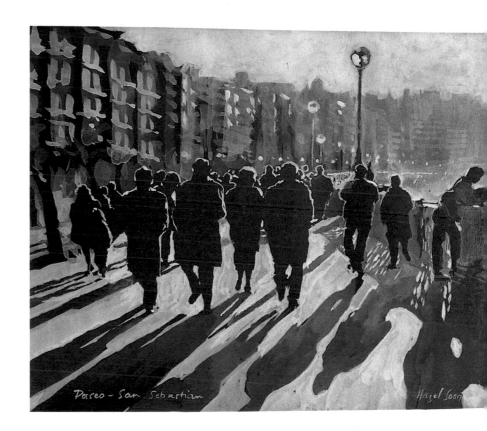

▲ Paseo, San Sebastian

HAZEL SOAN, GOUACHE

Light and shadow identify the movement in this almost monochrome, highly atmospheric gouache. The low winter light stretches and elongates the indigo shadows, which magnify the moving steps of the figures. Caught mid-step, with their bodyweight balanced on one foot, the individual characteristics of the figures are expressed in this moment of suspended action.

▲ Sea breezes

Denise Burns, oils

The figurative differences between children and adults are used to capture this fleeting scene, especially in the way that the children's movement is less fluid, balanced and stable compared to that of the adults. The little girl needs the support of her mother as she steps awkwardly over the wave.

with the physical action will make a nonsense of your image; they must relate to one another. Imagine a runner on a track; the set of a firm, rigid mouth and the direct gaze from beneath slightly furrowed brows indicate determined concentration. If the runner had fists clenched and taut muscles, but a relaxed mouth and calm eyes, the image would instantly lose all its impact.

Movement

When portraying a figure, always be conscious of body structure. Think of the skeletal shape, the covering muscles, and how the muscles and bones are attached. In effect, you must look through the body shape demanded by the movement to understand how it is formed. Then you can accentuate muscle form with tonal shading to emphasize the action. However, other qualities also enhance the effect of movement. The balance of a figure, the play

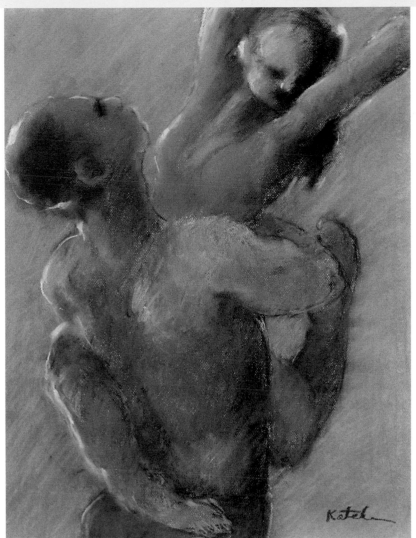

◀ Adagio

CAROLE KATCHEN, PASTELS

The physical exertion of this pose is mirrored in the dancers' facial expressions. Sweeping pastel strokes etch the male dancer's tautly arched back and imply the power in his support of his partner. The conflicting dynamics of balance in the pose, emphasized by the arcing lines of her arms and his back, create great energy.

▼ Dancers' workshop

TOM COATES, WATERCOLOURS

Loosely worked watercolour rather than a linear depiction of forms and shapes, captures the essence of the action. A suggestion of the dancers' moving shapes, reflected in watery shadows on the polished floor, conveys a sensation of articulate and delicate movement.

▶ **Welsh
jazz man**
ROSIE SAYERS, PENCIL
*A frenzy of energetic
gestural strokes
portray this robust
musician. The
vigour with which
the fast-moving
hand and elbow are
depicted, combined
with the dark
intensity of the
facial features,
expresses terrific
energy, and this is
exaggerated by the
illusory impact of
the music itself.*

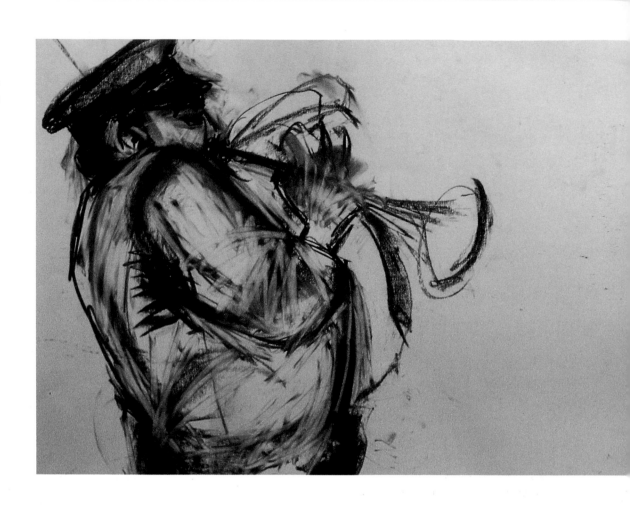

◀ **Going home**
LAVERE HUTCHINGS,
WATERCOLOURS
*The play of light
over the figure
indicates the action.
The supporting left
leg is evenly
illuminated, while
only the lower part
of the other leg
catches the light.
The right knee and
sole of the foot,
shrouded in a
contrasting shadow,
are bent in forward
motion. The angle
and tone of the cast
shadow relay the
pace of movement.*

of lights and darks, and timing all influence the degree of movement conveyed.

A shift of balance is a strong indication of movement. We have a logical understanding that if a figure is standing upright the weight is distributed evenly between both feet. When moving forward into a walk or run, all the body weight is immediately transferred onto one foot. The angle of the upper body tips forward, the hips tilt, the head bows and the arms begin to swing alternately to the legs. In portraying such movement, it is vital for the artist to convey this weight shift. The more this is emphasized, the greater the illusion of speed.

Light and shadow also play an important part in enhancing the illusion of motion. The artist introduces atmospheric vitality through the treatment of light, colour, shadow and the abbreviation of detail. The direction and strength of the light control the depth of the shadows reflecting the movement. Under a bright sun, highlights are magnified on skin tones or clothing as the

figure moves through the light. The exaggerated expanse of white accentuates the implied pace of movement. More muted tones tend to slow movement down.

The strength or weakness of a shadow describes how fast a figure is moving. A dark shadow with sharp outlines conveys a stationary figure, whereas a light-toned shadow with an indefinite outline suggests movement because the figure is not still enough to cast a firm, distinct shadow. Indistinct shadows also suggest that the figure is not in contact with the ground. In addition, shadows can indicate and anticipate the direction of the movement, since they are cast from the point that the figure has just left.

Capturing the right moment of the action is crucial. The artist aims to portray the instant, or split-second, to achieve greater emphasis. As in the chapter Movement and Colour, the trick of half squinting your eyes to study your subject is a great means of simulating the "glimpse" effect. It allows you to identify only the important features necessary to the impression of movement. As this gives you a heightened perception of the highlights and the coloured areas, so it also exaggerates the volumes and lines in the figures. This trick is particularly relevant in the next chapter on animals and birds.

The background enhances or "sets off" the mood of the picture. Remember, for anything moving you must allow space for it to move into. Too much detail in the background will detract from the main subject and swamp it. If your subject is moving at speed the background should be a shimmering blur. Colour adds panache while a shady background provides contrast and throws the main subject into the foreground.

In this chapter we have shown that painting figurative movement is about seizing a moment and supporting the illusion with elements of character and expression, while balancing these with well-judged anatomical reality.

▲ Streetwalking

CARL MELEGARI, COLOUR PENCILS

The unusual viewpoint allows the artist to convey walking people from an entirely new perspective. From this angle, the gap between one foot and another is clearly visible, emphasizing the fact that the figures are walking, and body forms and shapes are carefully portrayed to produce a convincing impression of movement. The lack of outline and mass of directional linear work leaves an extremely effective, impressionistic, image of fleeting action.

EXERCISES

Soft, fluid marks, strokes and lines will give a more convincing impression of figures in movement than over-detailed work, which tends to look more static and "freezes" the subject in mid-pose. However, detail used judiciously can draw attention to the focus of the action, as can colour, or an interplay of light and shadow. Although you should avoid over-working your moving figures, you will still need to give some sense of the anatomical form underlying each movement if your picture is to look convincing.

▼ Creating an impression

Careful observation is the basis for creating the optical illusion of a mass movement. In this crowd scene, presented first in ink and wash, then in watercolour, only the shapes, lines and shadows that suggest the impression of jostling movement have been included, capturing the effect of a momentary glance.

The well-known expression "less is more" is very true here. The crowd is depicted in black and white, using shadow and line to convey the moving figurative positions.

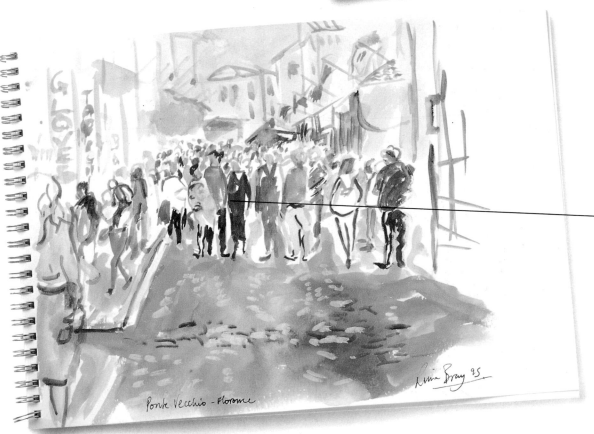

Ponte Vecchio - Florence

Colour immediately creates an atmosphere in which the walking crowd jostles together. Loose, watery washes enhance the overall sense of movement. Although the figures are still mono-chromatic, the eye is drawn through the more intensely coloured foreground to the heart of the picture.

▲ **Selective detail**

The delicate detail in Zsuzsi Roboz's charcoal drawing of Nathan Milstein intensifies around the peak of the action to emphasize the drama of movement and music. The violinist's hands and arms are lightly sketched in to contrast with the focus of interest around the face.

◄ **Underlying anatomy**

A knowledge of anatomy is essential for conveying a truthful image of the moving figure. In Tom Coates' Dancers warming up a wonderfully "elastic", washy watercolour technique is used to describe the flowing balanced action of the dancers.

The two right-hand dancers are poised in the middle of moving. Their arms, bent at the elbows, portray how they are carefully balanced on one leg. Their other legs, feet and heads diffuse gently into the background, presenting an almost vaporous impression of movement.

Rhythm and balance

When a figure walks slowly, you have time to observe the fluid swing of the hips and the effect this has on the torso, shoulders, arms and legs. Look for the changing angles of the hips, shoulders and head and the twist of the back. If the figure is carrying something heavy, the momentum is exaggerated to compensate for the weight. This project is designed to capture an instant in this rhythmic action.

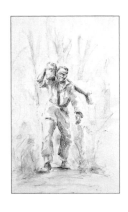

A preliminary sketch will help you decide which areas to focus on in order to influence and exaggerate the impression of movement.

Materials used

500g/m² (240lb) watercolour paper

•

Watercolour paints

•

Sable brushes

•

Very soft aquarelle pencil

•

2B pencil

1 *Make an outline sketch to position the figure on the paper. Starting with the background, paint a wash of clear water over the paper and then apply a dilute wash of cerulean blue and hooker's green. Next, introduce touches of green and yellow ochre washes for the sunlit leaves. The colours will mix on the paper to produce an illusion of distance. Hold your brush almost at the end of the handle for a looser, freer movement.*

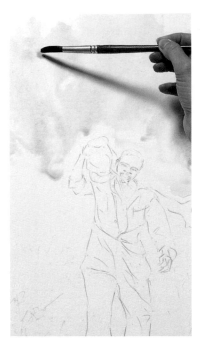

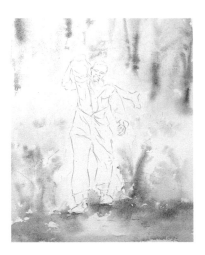

2 *While the paper is still wet, put in the rest of the scene around the figure with watery washes: feed in slightly darker tones for the tree trunks and warmer colours in the foreground, letting colours blend together. Allow them to dry before starting on the figure.*

3 *Apply washes to the area of the blue boiler-suit before applying any colour, leaving areas dry to stand out as highlights. Working from light to dark, apply washes of cerulean and ultramarine and allow them to blend and bleed on the paper. Add denser shaded areas when the paper is nearly dry so that it does not spread too much.*

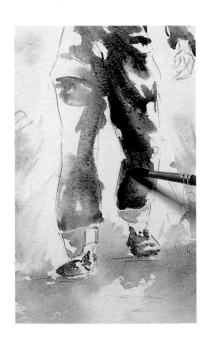

4 Mix the base skin tone of the figure. A darker tone can be fused into it to create the shadow and body form. Leave a dry, unpainted area for the highlight on the arm, continuing its shape from the boiler-suited elbow. For more control in these more detailed areas, hold the brush nearer the tip.

5 Put in the fall of the shadow down the leg and onto the shoe to lend substance and weight to the subject. Use a warmer hue to add the ground shadow.

6 Finally, rub out any unnecessary pencil marks from the original sketch and then accentuate the highlights of the figure's outline in pencil.

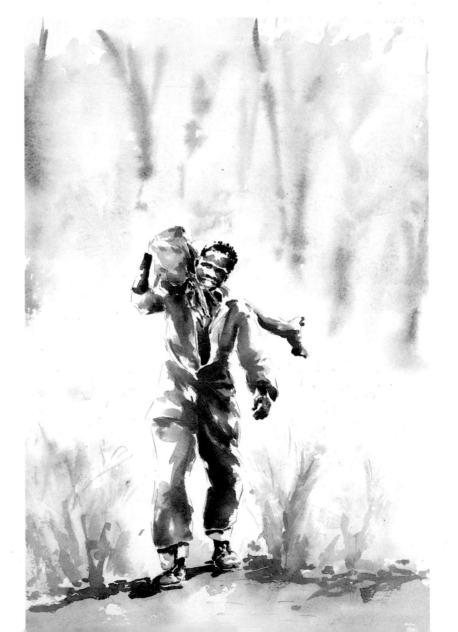

▶ **Jacob**

JULIA CASSELS

Highlights rebounding off the darks emphasize the man's movement through the light, and their directional shapes across the figure draw attention to the twisting swing of his rhythmic action.

Coloured shapes and shadows

Shadow patterns can become vital elements in a composition, as they convincingly indicate, and sometimes emphasize, the action. Here, the reflected shadows in the wet foreground are vital for supporting the twisting, jumping shapes of the dancers. Squiggly brushwork, contrasts between thickly and thinly applied acrylics, and the interchange between acrylics and pastels are used to convey the sense of movement.

In the reference photograph there is a clear space between the dancers and their reflected images on the wet surface.

Materials used

600g/m² (300lb) watercolour paper

●

Acrylics, watercolours, chalk pastels, conté crayons

●

Hog-hair and synthetic brushes

●

Rag

●

Charcoal pencil

1 *Lay a loose ground wash, and knock it back by rubbing it with a rag. Then lightly sketch in the initial composition with pencil.*

2 *Using the pencil markings as a guide, block in the preliminary areas of colour with very diluted acrylic.*

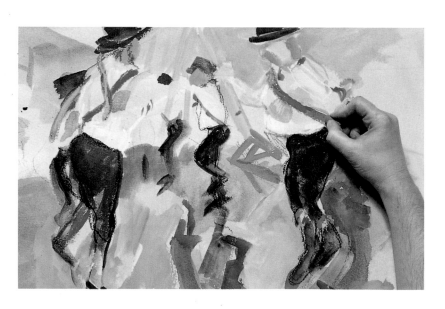

3 *Now that you have most of the basic colours roughly painted in, you can begin to concentrate on the detail. The dancer's painted blue sash is enriched with pastel to emphasize the movement and sheen of the fabric.*

4 Even before the details are all added in, the contorted images of the dancers are robustly reflected in the ground. The space between the jumping dancers and their reflections strongly indicates that they are captured in mid-air.

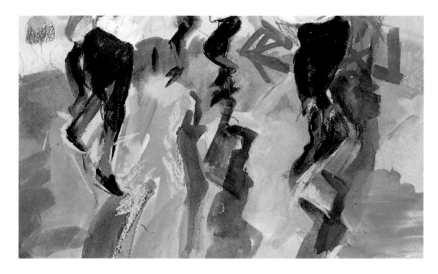

5 Use white pastel with its characteristic broken grain to pick out the highlights.

6 Use charcoal pencil to lightly draw in some of the background details and figures.

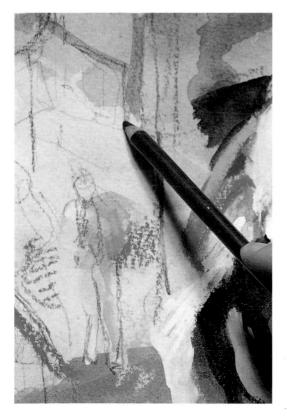

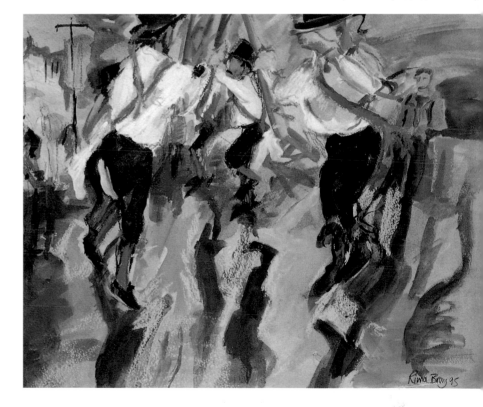

▲ **Morris dancers**

RIMA BRAY

The spaces between the figures and their reflections is of vital importance in this mixed media composition. The painting is initially built up with acrylic and watercolour paints. Pastels are then used to strengthen the shadows on the ground and adjust the balance of foreground and background colours.

Movement & wildlife

For representing movement in wildlife, close observation is crucial. Animals and birds are continually busy – grazing, walking, galloping, flying or just fidgeting – so your chances to study them are limited. Catching them stationary will often mean they are sleeping and consequently motionless. When you do see them awake, notice how such characteristic features as fur, feathers or markings not only identify them, but emphasize movement. By taking the time to study these effects, the artist will be better placed to convey evocative, lively illusions of movement.

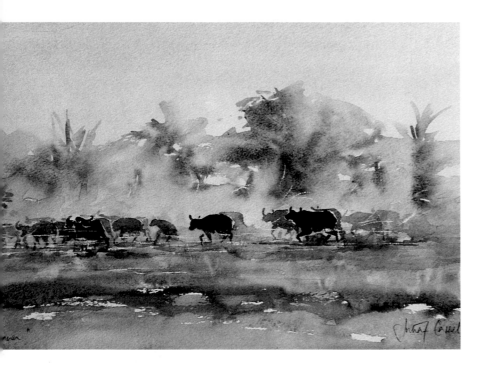

▲ **Buffalo at dawn**

JULIA CASSELS, WATERCOLOURS

Colour and shape create an atmospheric illusion of the moving herd of buffalo. Indistinct, pale buffalo shapes have been diffused into watery washes of veiling dust to suggest the animals' mass and pace. The darker, more clearly defined buffalo identifies the action and sets the herd's speed and depth within the landscape.

A nimals and birds have always held a fascination for artists. As early as 1500BC, man depicted buffalo and bison inside the ancient caves of Lascaux, France. Jackals and ibises pictorially record the life and beliefs of the Egyptians, while sculpted jaguars adorn the more recently discovered Mayan temples and palaces of Mexico and Guatemala.

We can watch creatures for hours, mesmerized by their movement, behaviour and character. Artists have always enjoyed the challenge of producing a true portrayal of creatures – articulate and fluid in movement, while at the same time impervious to man and intriguing in behaviour. You need to appreciate its true character to make a bird or animal seem alive – to capture its poise, stance and attitude.

Observation

Before you start to draw or paint your subject, spend some time watching it. Look at a horse grazing and learn how and in which order the legs move. Notice how one shoulder angles and tilts as the other front leg moves forward. See how the ears twitch,

▶ Elephant farewell

JULIA CASSELS, MONOPRINT

The spontaneity of the monoprinting technique is exploited to capture the characteristic impression of an elephant's lumbering walk. The calligraphic brushwork style and the areas of diffused colour embody the heavy form, lending impetus to the movement.

◀ Food on the run

NANCY FORTUNATO, WATERCOLOURS

The delicate colouring of the beautiful, arched shape captures the apex of the action. The artist includes just enough detail on the head and wing-tip to express the immediacy of this seized moment. Contrasted with the more fully painted static bird, the motion is emphasized further.

the tail flicks at flies, and the neck holds the head. Study the supple changing alignment of hock, hip and hind-quarters. Effectively you are gaining an understanding of how the muscles and bone-structure works beneath the skin, which is essential for displaying a realistic impression of animal movement.

Without taking your eye from the horse, use a pencil or piece of charcoal and follow the flow of the legs and curve of the neck onto your paper. As the artist, you are reacting to the momentum and rhythm of movement. Select lines that follow the direction of the movement through the body, such as the sinuous curve of the neck and spine of a charging cheetah or the undertail to planted flat foot of a waddling duck.

In many situations it is not possible to observe at leisure. Out in the wild you might only have the chance to catch a momentary glimpse of your animal. Though antelope may roam freely they are skittish, as are baboons and monkeys when startled. In an instant they disappear high up into the tops of trees, or scatter into the bush. Giraffe and warthog are also notoriously shy and furtive. Of the big cats, seeing a leopard is a rare

treat. Elephants, however, perform beautifully for artists – browsing, wallowing in waterholes and throwing dust over themselves as protection from the harsh sun, totally unphased by your presence. It is worth spending the first opportunity you have in just observing them. Digest as much as you can about their movement, make-up and behaviour. If you are lucky enough to see them again, scribble as many quick sketches as possible, while watching them the whole time. Try to photograph the scene for reference before they disappear. Later you can piece a picture together from your sketches and the colour and tonal information from the photograph.

Birds behave in a completely different manner to four-legged animals. On landing, they balance on their two legs, using their tails as stabilizers. They hop awkwardly and are rather ungainly on the ground but, with wings outspread, they can fly gracefully and with apparent ease. Unfortunately, birds are never as easy to study in flight as they are on the ground. Chickens, for example, have a very sudden, jerky, almost staccato action as they peck for food. Ducks waddle with a

◀ **Two from home**

Jonathan Trowell, pastels

The increasing detail draws the eye along the fluid line of the back and arch of the neck to the head. The horse's keen eye reflects the exertion of the action. The vague image of the nearest jockey, and the even fainter outline of the further one, express the impact of speed.

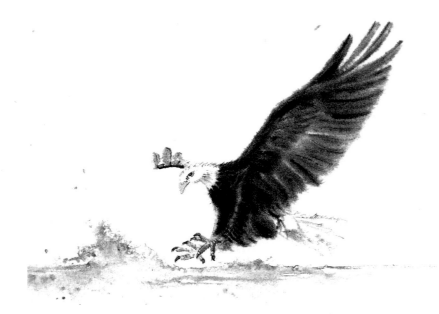

◀ Quiet fisherman

NANCY FORTUNATO, WATERCOLOURS

The anticipated action contains a dramatic sense of movement. The fish eagle is caught at the climax of the swooping action, just before the kill. The linear angle of the huge, outstretched wings accentuates the downward force and impact of the plunge.

laboured roll from side to side, as if they are in fear of tripping over their webbed feet. In flight birds are often too far away and only present silhouetted shapes in the sky. On water they glide effortlessly, trailing behind them their reflected form, distorted by the ripples of their wake.

In all cases there are exceptions to the rule – the ostrich, penguin and kiwi immediately springing to mind. These are birds thwarted by their inability to fly. The ostrich has adapted to this handicap by developing enormous power-packed legs which operate in reverse to those of a human. The knee bends backwards to the ankle joint, from which stretches a three-foot long foot. Getting back onto four legs, the camel and giraffe walk with both right or both left legs moving in unison.

Remember that photographs are a wonderful source of reference, but they have their limitations. A photograph is a freeze-framed representation, whereas your own quick sketches – despite any inaccuracies – will be impromptu and alive. By using a combination of sketches and photographs, you can understand your subject in greater depth. Since photographs record in closer detail, use them to absorb colouring and markings, and other particular features. It is always better to use your own photographs, as you will have caught the action you

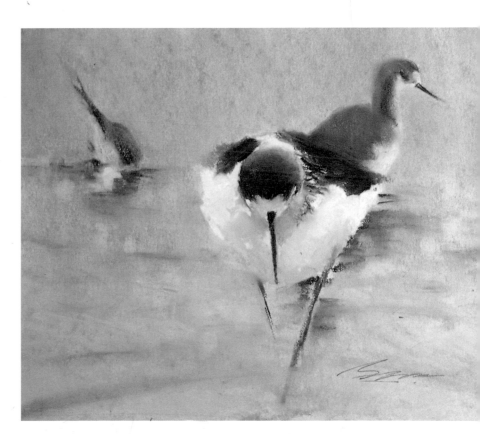

▲ Fandango

JANN T. BASS, PASTELS

The sharp focus and inclusion of detail indicate a slow pace. The impression of forward movement is clearly suggested by the colour and detail on the near leg compared to the fainter image of the other leg.

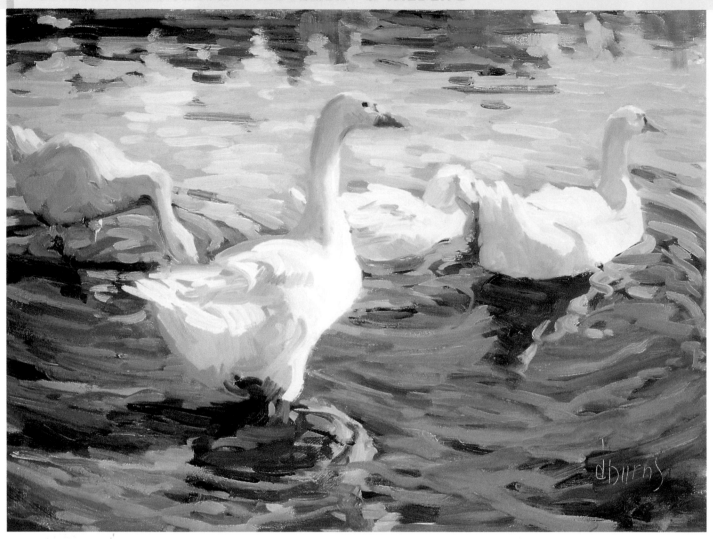

◀ **The herd approaching**

HAZEL SOAN, WATERCOLOURS

A sensuously evocative impression of distance and depth projects the elephants in their forward motion towards the water. The shapes of the distant elephants fade under subtle watercolour washes.

◄ **Four duck play**
DENISE BURNS, OILS
*The artist has
created a sense of
gentle motion
through a clever use
of colour and
brushwork. The
radiating ripples
preceding the duck
suggest its
movement. The
broken reflections
further exaggerate
the subtle motion*

specifically wanted. If borrowing from books, magazines or libraries, you will find yourself having to compromise on shape, angle or position. Videos have now opened endless opportunities for observing wildlife. They allow the artist to rewind, if necessary, and freeze a particular movement.

Behaviour and characteristics

Infusing your drawings with identifiable and idiosyncratic characteristics lends realism and credibility. If you have observed them carefully before drawing them, you will have

learnt that certain characteristics are unique to both the appearance and behaviour of each animal or bird.

You will have seen how a chicken's feathers stick out like the prickles of a sea urchin when it cranes its neck forward to peck at food. Watch a flock of pelicans flapping their wings and feathers; notice how the large wings unfold from the body, and how the bird's floppy yellow bill extends and contracts. Baboons and monkeys can often be very comical. The way they move their digits when de-fleaing a neighbour, or their facial expressions when reprimanded, are

◄ **Turkey tango**
JULIA CASSELS,
MONOPRINT
*The exciting imagery
of flapping,
oscillating
movement is
apparent in the
highly sensitive
brushwork. The
artist has captured
the rotundness of
form and
characteristic
motion through
gestured flicks with
a well-loaded brush.*

astonishingly human. So it is hardly surprising to learn that a baboon striding away on long legs, swinging his bottom like a pendulum, is pigeon-toed. But we are far more familiar with domestic animals, particularly our own. Generally, it won't be necessary to spend so much time looking at the cock of the dog's ears or the wag of his tail. Instead you will be looking for attributes unique to the individual animal which, as an artist, you must strive to bring alive in your work.

Fur, feathers, beaks, claws, tails, markings and horns add to the charismatic whole. The artist's treatment of such features through varying painting techniques can describe the velocity and power, or the reticence and delicacy, of a particular bird or animal. For example, a quick, fluid stroke of the brush, charcoal or pencil can indicate the tusks of an elephant or the horns of an antelope. A dry brush or pastel dragged over rough paper suggests the texture of fur. A sweeping line, flicked at the end of the stroke, evokes

▶ **Zebra crossing**
JULIA CASSELS,
WATERCOLOURS
Watercolour is used quite dry, with gestural flicks of the brush, to suggest the impression of movement. The legs disappearing into the grass creates a feeling of speed.

◀ **Finishing fast**
CONSTANCE
HALFORD-
THOMPSON, PASTELS
The main shapes of the horse and driver are roughly blocked in with a combination of solid colour and loose linear marks that both extend into and are overlapped by the background, blurring the outlines and creating a dynamic impression.

the beating wing of a bird in flight or the mane and tail of a galloping horse. A streaming mane, a flick of the tail, or the angle of the horns can add emphasis to the motion. The artist often exploits and exaggerates such features to accentuate the fluid line of movement, anticipating its direction and swiftness. Although a zebra wouldn't be a zebra without stripes, to include every stripe on a running zebra would detract from its illusion of speed. The artist needs to include just enough – the kick of the tail, the flaying hooves, and a suggestion of stripes on the body – to express its speed. It should appear as if you just had time for a second's glance as it sped past.

By placing your moving creature against a background, you are effectively authenticating it in scale and atmosphere. Some wildlife is intelligently camouflaged, integrating wonderfully into its surroundings, melting into the kaleidoscope of sepias, ochres and earthy hues. This can make it tricky for the artist to define them in their background. On

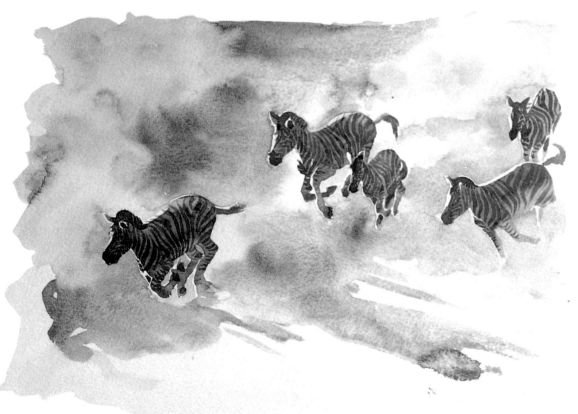

◄ **Raising dust**

HAZEL SOAN,
WATERCOLOURS
The illusionary effects of dispersing dust, counter-balanced by the elongated shadows, evoke the sensation of galloping zebras. Some hooves are clearly visible in mid-air, while those on the ground dissolve into the dust, creating an impression of pace.

▶ **Advancing hippo**

JULIA CASSELS,
WATERCOLOURS
The unpainted areas play an important role in suggesting the movement. As the light direction is constant, so too are the rebounding shadows, but the effects of light over the moving hippo and the disturbed water are incessantly changing. The broken reflections extending from the concentrated mass of the body sustain the illusion of the hippo's movement through the water.

the other hand, the background can be used to enhance the sensation of speed. Fussy backgrounds tend to distract, but when your image moves at high speed, its surroundings blur into insignificance. The use of contrasting tones, shadow and "colder" hues will help push the background back and, at the same time, throw your main subject into the foreground. Most important of all, you must allow an expectant space for your creature to leap, gallop, dive, walk or fly into.

In summary, to achieve movement in animals and birds, the artist needs to include just enough detail to create the impression of, and anticipate, the action. By including subtle hints of its character, behaviour and attitude, movement can be portrayed with captivating authenticity.

▶ Out of the trap

JONATHAN TROWELL, CHARCOAL

The undulating line and contorted shape of the greyhound create a highly energized image. The densely smudged charcoal line expresses the tautness of the stomach muscles, and the darker areas that explain the action are emphasized by the suggestion of the arched back and haunches, increasing the impression of speed.

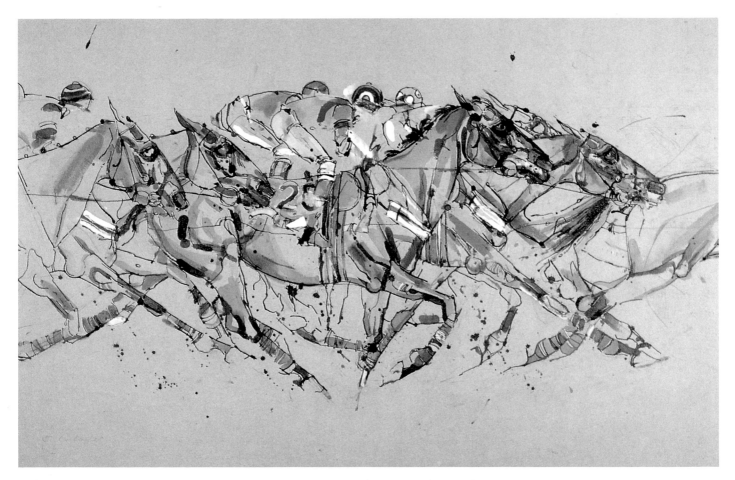

▲ The race

JO TAYLOR, PEN AND WASH

Concentrating on the muscular forms and outlines of the subject, the artist gives the image a graphic quality. The linear pen-work, enhanced with muted areas of flat wash, is highly effective in transmitting the shape of speed.

EXERCISES

As with figure work, quick, loose marks and brushstrokes better convey the fleeting quality of a moving animal than does a wealth of detail. Nevertheless, your drawing or painting will work better if you bear in mind the anatomy underpinning each movement. Sometimes the sheer mass of an animal, as in the elephant opposite, can be used to suggest its weighty, lumbering gait. The action of individual parts – the sideways swing of a trunk, the backward swish of a mane, the upward flick of a tail – can also give extra momentum.

▼ Looking at anatomy

In drawings of figures or animals, movement can be conveyed by describing the muscle form and skeletal shape although a knowledge of anatomy – particularly muscle/bone relationships – is needed in order to make the image convincing. An artist will often accentuate these elements in order to give greater emphasis to the action.

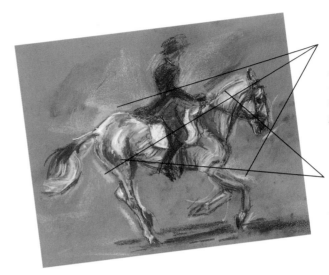

The structure and form of the horse in "mid-prance" are described by outlining its shape with brisk strokes of pink pastel.

Highlights are used to exaggerate the muscle form of the arched neck and taut flank.

▼ Fleeting impression

Sfumato (an Italian term meaning smoke-like) is a visual effect rather than a technique, and it is entirely appropriate for conveying the impression of a moving subject. It relies upon the illusion created when tones or colours merge softly into one another rather than being separated by hard lines.

3 *Having built up the darks again, knock them back into the paper surface by smudging them with a finger.*

1 *Block in the initial colours lightly using the side of the pastel stick.*

4 *Build up repeated layers of pigments, working from light to dark, blending them with a finger or torchon as you go to produce a soft, colourful impression that is entirely devoid of linear structure.*

2 *Using a torchon (a narrow strip of blotting paper rolled into a pencil-like stubb), press the pastel gently into the grooves of the paper surface and blend them softly together.*

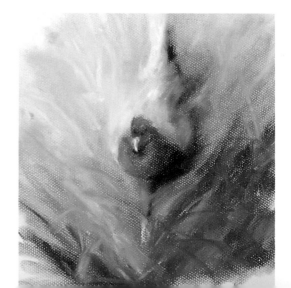

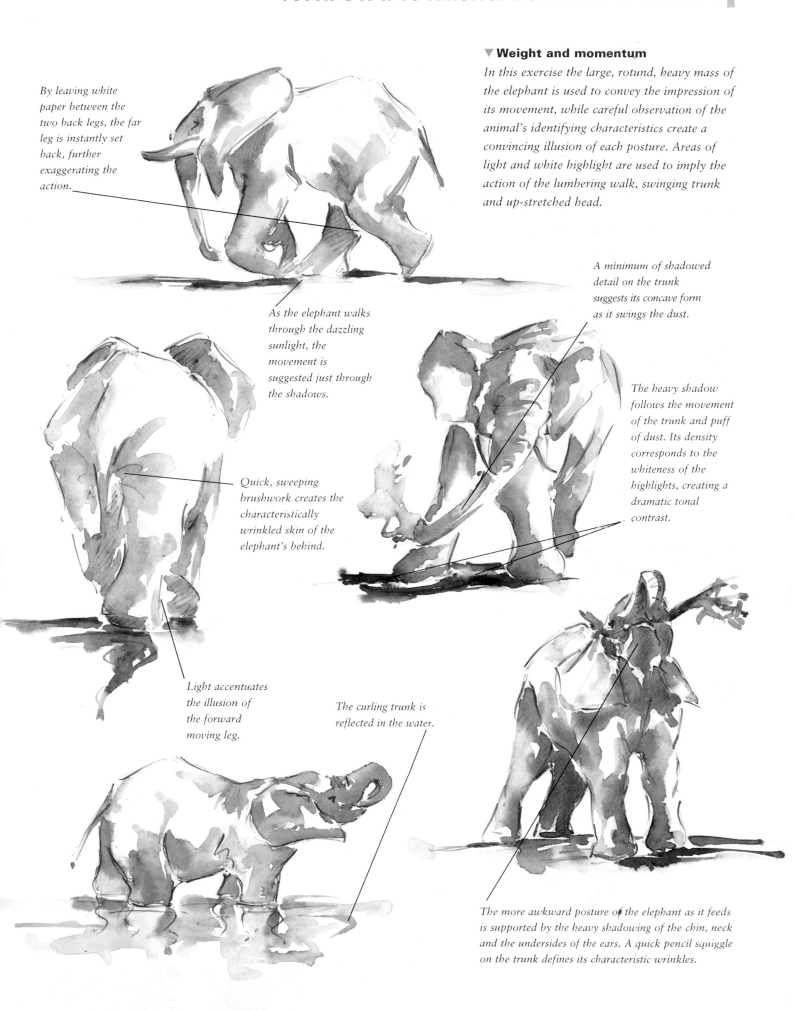

By leaving white paper between the two back legs, the far leg is instantly set back, further exaggerating the action.

▼ Weight and momentum

In this exercise the large, rotund, heavy mass of the elephant is used to convey the impression of its movement, while careful observation of the animal's identifying characteristics create a convincing illusion of each posture. Areas of light and white highlight are used to imply the action of the lumbering walk, swinging trunk and up-stretched head.

As the elephant walks through the dazzling sunlight, the movement is suggested just through the shadows.

A minimum of shadowed detail on the trunk suggests its concave form as it swings the dust.

Quick, sweeping brushwork creates the characteristically wrinkled skin of the elephant's behind.

The heavy shadow follows the movement of the trunk and puff of dust. Its density corresponds to the whiteness of the highlights, creating a dramatic tonal contrast.

Light accentuates the illusion of the forward moving leg.

The curling trunk is reflected in the water.

The more awkward posture of the elephant as it feeds is supported by the heavy shadowing of the chin, neck and the undersides of the ears. A quick pencil squiggle on the trunk defines its characteristic wrinkles.

10

Dark against light

The presence of moving wildlife is often betrayed by the voluminous, effervescent dust clouds kicked up in their wake. The animals themselves can be depicted as vague shapes seen through the veil of dust. The trick is to depict the vaporous dust with layers of washes and let them diffuse loosely into very wet paper so that there are no hard edges.

The fractured images of the animals through the enveloping dry dust create a highly charged illusion of the space and depth of the African bush.

Materials used

600g/m² (300lb) watercolour paper

•

Watercolour paints

•

Sable brushes

•

Sponge

1 *Wet the entire surface of the paper and lay a strong yellow wash, leaving a space for the dust cloud on the horizon. The wash will gently fuse into the dust cloud.*

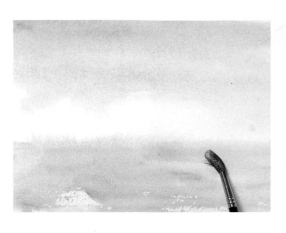

2 *Add dabs of light red into the still-wet sky to create the cloud base. When the paper is almost dry, add blades of grass so that they bleed only very slightly.*

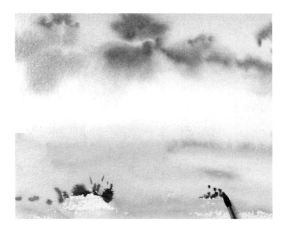
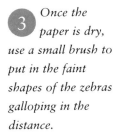

3 *Once the paper is dry, use a small brush to put in the faint shapes of the zebras galloping in the distance.*

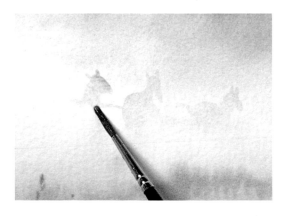

4 *Increase the intensity of the colour of the running animals towards the foreground to support the impression of depth within the painting.*

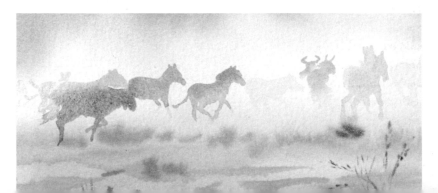

5 The twisting
form of a
shying zebra can be
used to capture the
impression of
motion.

6 Returning to the foreground detail, use a
sponge to create the speckled hazy look of
the scrub half-enveloped in dust.

7 Wet the sky
area again and
add a deeper tone to
counterbalance the
animals. Allow the
colours to bleed.

▶ **Zebra and
wildebeest in
flight**
HAZEL SOAN
The final picture
evokes the heat and
smell of the dust,
and the limited
palette of rich,
warm, earthy
colours captures the
illusion of distance
and mood, together
with the electric
impact of
movement.

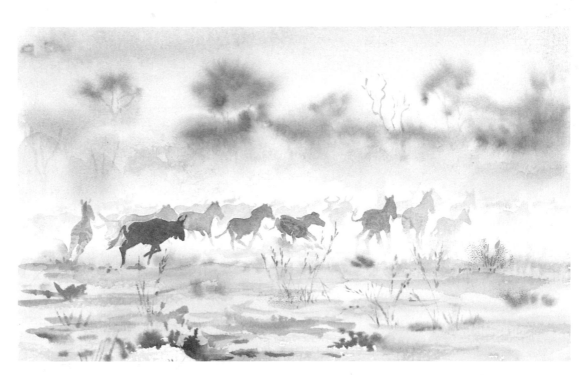

PROJECT 11

Maximum speed through minimal brushwork

The expression of movement through brushwork is a practical skill that depends on knowledge of the medium and its limitations. The translucent nature of watercolour provides a range of ways of setting the scene – from loose washes to tight detail – while confident brushwork expresses the energy, creating the illusion of impact with an atmospheric, light, luminous and lively quality.

Definite and directional linear work in the quick pencil sketches clearly indicates the urgency of the racing greyhounds. The detail of the eye, set of the mouth and the moving shadows are important, and emphasize the illusion of speed.

Materials used

180g/m² (90lb) Saunders rough watercolour paper

•

Watercolour paints

•

Fine Chinese water brushes

•

2B pencil

① *Begin by pencilling in the shape of the greyhounds as a guide, before wetting the paper with a sponge. Lay in the initial background washes loosely, leaving the greyhounds white. Then use a Chinese brush, which holds more water than a conventional brush, to block in the dog's race number lightly.*

② *Add stronger washes in the foreground, and then work a loose wash wet on wet in pale grey. Allow it to diffuse to give the impression of vaporous dust kicked up in haste by the greyhounds.*

③ *A diagonal sweep of strong yellow adds the impression of uplifting movement to the leading dog. The effect of this streaking brushstroke can be seen in the finished painting.*

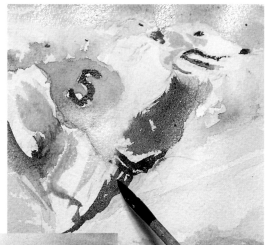

4 Returning to the greyhounds, paint a strong, greyish-brown wash over the dry paper surface to mark the contrasting shadow on the body of the greyhound. This successfully throws it to the foreground. By applying the paint to dry paper, you can achieve a hard edge between the white and brown. Paint applied to dry paper also has a broken, textural quality that breaks down detail, thus emphasizing the dogs' speed.

5 A long stroke of warm golden brown forms the shadowed leg of the leading dog. Leave the tops of the head and shoulders unpainted, accentuating the feeling of speed as the greyhound flashes through the sunlight.

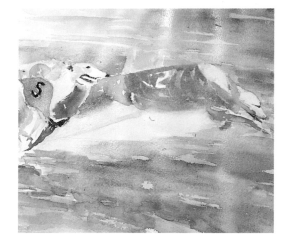

6 Leave the painting to dry for half an hour before adding second washes in the background and foreground, as deeper colour will produce depth, volume and substance.

7 Leave the painting to dry again, and then use the tip of a Chinese brush to dab in the spatterings of flying mud.

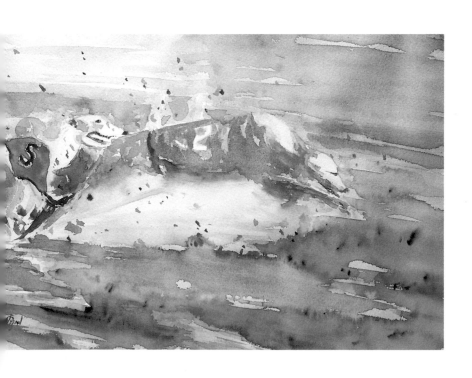

◀ **Greyhounds**

GLEN WAWMAN

An illusion of speed is achieved through a combination of wet and dry brushwork. By working wet into wet, wet into semi-dry and directly onto dry paper, it is possible to create the blurred effects of speed, broken forms, and just enough detail to support this image.

Movement & landscape

Movement *and* landscape sounds like a contradiction in terms. Land is a solid mass and a secure, firm base. But the landscape *does* move as it reacts to changing light and the forceful elements of wind, rain, snow and storm. Trees, grasses and flowers, for example, succumb to elemental forces in a variety of ways which allow us to recognize movement. As the artist, it is up to you to impart this feeling of space combined with movement, instilling your picture with a lively atmosphere.

◀ **Melt water**

DOUG DAWSON, PASTELS

The feeling of movement in the landscape is suggested through the treatment of colour and brushwork. Doug Dawson has used a variety of irregular pastel strokes to convey an impression of the running, gushing water. The broken, slightly blended colours blur the grass and sky, creating the feeling of a constant breeze. The sensation of movement in the landscape is exaggerated through the contrast with the solidity of the rocks.

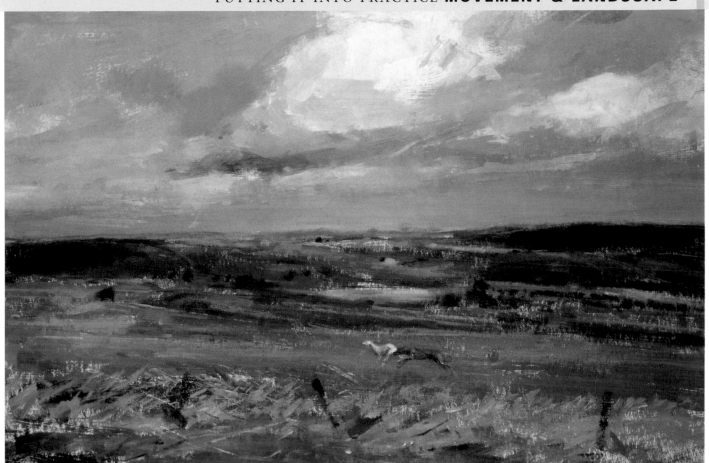

L andscapes vary enormously in terrain. Depending on the location and climate, two landscapes can feature entirely different vegetation, colour patterns, textures and forms. Development and cultivation by man will alter appearance even more. Take a look at the work of Cezanne: his evocative colours, shapes and vegetation firmly localize his impressionistic landscapes in the plains of dreamy Provence. Whatever its situation, the landscape will always react to the external elements of weather. Such reaction causes colours to change, the vegetation to become animated, transforming the surroundings into something wild, romantic or even sinister. The climatic elements of movement leave no part of the landscape unaffected.

Observation

In the previous two chapters, we discussed how observation is essential in learning to convey the impression of movement. It is equally as important here, but it is a question of how to look, and what to look for. On a windy day you can feel the wind, but you also see how the trees have been tugged and pulled into different shapes. Grass, too, bows in the wind to produce a new, uniform sheen and texture quite different to what we normally know. Up in the sky, clouds race across, with their shadows correspondingly chasing each other over the ground. Smoke from chimneys drifts voluminously in a well-defined direction until it eventually evaporates. It is as if all these elements are characters in a drama, and it is this drama that signifies the movement in landscape.

Somehow, this is all so familiar, we rarely take the trouble to study it. It is worth taking a photograph of a particular scene on a calm day, then another on a blustery day, and noting the comparisons. In this way you will be able to see the transfigured shapes of the trees, the bend of the grasses and the change of colour patterns. Similarly, make some quick sketches to record the altered states.

If you introduce figures into your landscape they must be consistent with what is

▲ **Dog days in Derbyshire**

JONATHAN TROWELL, OILS

The blustery wind is evoked through hectic, directional brushwork. Thick, gestural strokes of pale oil paint over darker tones create an illusion of wind-blown grass. Light, directional strokes and streaks of colour dragged on with a palette knife exaggerate this impression. The running dogs, battling against the wind, set the scale of the landscape.

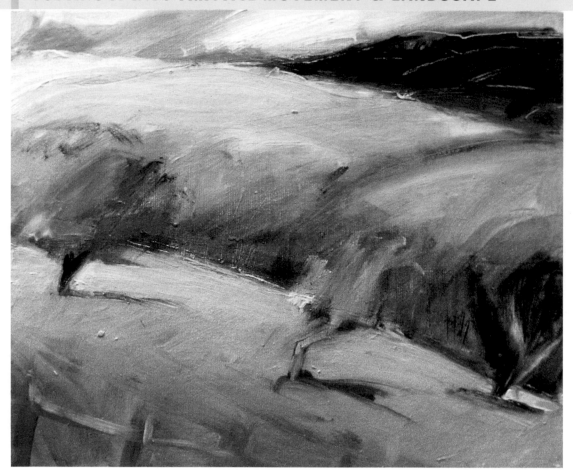

◄ Troutbeck

JANE STROTHER, OILS

The force of the wind is emphasized by the surging, directional brushwork over the hills and distorted trees. The moody colours, exaggerated by the extended shadows, portray a charged atmosphere.

► A woodland path

ALAN OLIVER, PASTELS

The light hues and varied pastel strokes create a tranquil atmosphere. The effects of the gentle breeze can be seen in the blurred, irregular strokes and varied colour juxtapositions.

▶ **Lady lake**

JANN T. BASS,

PASTELS

Smudged, sweeping marks of directional pastel gather in detail and draw us into the scene, illustrating the illusion of movement over the grass. This movement is supported by the clouds, which appear to roll in the opposite direction to the blown grass, lending greater impetus to the circulating pull of the wind.

happening in the rest of the scene. Through their reaction we are able to understand and gauge the force of the wind, the drive of the rain or a peaceful summer breeze. Likewise with animals and birds – their attitude must be in sympathy with the motion happening around them. If all the trees and shrubs were blowing in one direction, and the coats, scarves and hair of your figures in the other, your picture just would not make sense. The artist should seize upon the human, animal and otherwise natural elements within the landscape and use them to emphasize the movement of the main subject.

Varying the media

By using a variety of media and techniques, the artist is able to portray light or heavy cloud and swirling breezes convincingly. The result should make you feel as if you can actually experience the sunlight of a summer's day or the biting winter wind. Colour can also assist in conjuring up the mood. The cooler colours – viridians, indigos, cerulean and prussian blues – imply cold, and the warmer – ochre, burnt siennas, india reds and vermilions – inspire a feeling of heat. When juxtapositioned the contrasts can achieve a real impact.

Watercolour allows the artist to use the marvellous translucency of tonal washes to build an impression of warmth or cold, leaving the strategically unpainted areas to act as the highlights of directional sunlight. Shadows of the clouds whizzing across the sky appear stronger and more focused in the foreground, then fade in tone and and clarity as they disappear into the distance. The shadow's directional diminishing emphasizes the wind movement and hint at its speed. Using a drier brush, the artist can describe,

almost calligraphically, the wind's forceful pull on the trees and other vegetation.

Oils possess qualities of flexibility. Artists can exploit their glutinous consistency by dragging the brush to evoke wonderful movement. Van Gogh particularly exploited this quality to superb effect. The malleability of pastels makes them particularly suited to capturing the imagery of the landscape. *Sfumato*, broken colour and gesticulatory linear work comprise a vocabulary of effects that instill movement in a picture – whether distorted by rain, windswept, or shimmering in a summer breeze. Pencil and charcoal, being more immediate, require only a few calligraphic marks to register action.

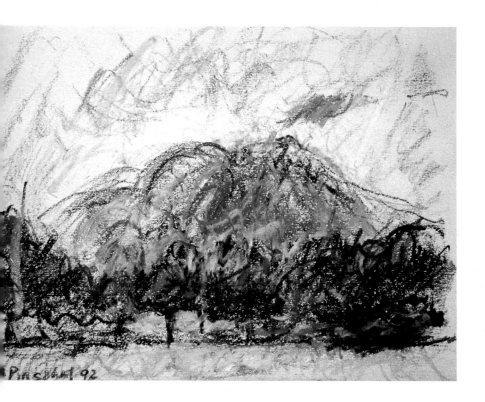

▼ Cromer in February
ALAN OLIVER, WATERCOLOURS
The sensation of the incoming storm, expressed through the fountain of pewter cloud, is echoed in the wet sand. Working into wet paper, the artist creates an atmosphere of cold wetness by allowing the watercolours to diffuse together on the paper.

▲ Fruit trees
M. PINSCHOF,
PASTELS
Pinschof's fruit trees are described with a wonderful chaotic sketchiness, which is echoed by the hill in the distance. Their exaggerated forms, enlivened by wild, strong, emotional strokes and enriched with colour, create a dramatic impression of incessant motion.

▼ Nova Scotia

C.M.U. HENKEL, OILS

The use of complementary colours accentuates the movement in the sky, the cool blues and warm oranges enlivening each other. The lit sky and the orange-tinged slope rebound off the dark trees and greenish foreground. The listing trees, grass and lone branch add greater impetus to the emotional movement in the sky.

▶ Grasses and sow thistle

BRIAN BENNETT, OILS

The contrast between warm gold and cool blue emphasizes the brewing storm. The small areas of intense colour rebound against the less saturated colour in the sky, and draw our attention to the sweeping movement of the grasses.

▼ **Autumn clouds and hills, Moel-y-Gest, N. Wales**

JANE STANTON-WILSON, OILS

The impact of such intense and powerful colour, coupled with the expressive brushwork, evokes the magnificent drama of the storm. The enormity and darkness of the foreboding hills are exaggerated by the minute row of trees in the foreground. The upward-sweeping brushstrokes of blended oil paint have distorted the horizon, emphasizing the depth and turmoil in the scene.

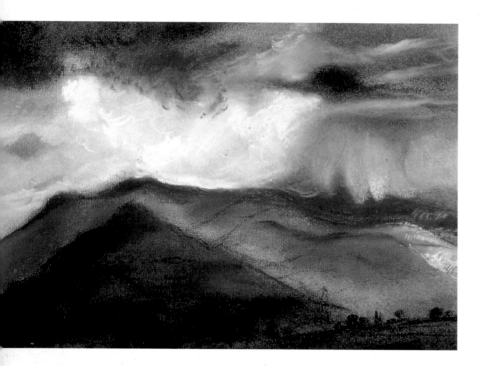

Changing the viewpoint

Landscape can move if we put *ourselves* in different situations. Instead of experiencing its movement "en plain air", supposing you move indoors and watch it from a window. This viewpoint allows the artist to discover the contrasts between the static and moving, emphasizing the movement to greater effect. It juxtaposes the sensations of motion and immobility, chaos and calm, almost to the point of allegory.

You can develop this further by placing yourself in a moving vehicle. The landscape takes on an almost surreal aspect as it flashes past. As the speed increases, the chance to focus on any individual feature becomes impossible, everything merges into a blur. This opens endless possibilities for the abstract. If you half squint your eyes – as before – to "glimpse" the scene from within a train, car or plane, it is fascinating to see which colour dominates as the landscape blurs. In different countries, terrains and climates, the colour will be different.

The background of a landscape is an integral part of the picture. It expresses distance and depth. As everything recedes into

▶ **Sunshine and smoke**

BRIAN BENNETT, OILS

A much calmer, cooler mood is evoked in this painting compared to that above. The radiating, smokey sunlight illuminates, enhances and distorts everything it touches, creating a blurred illusion of moving, fractured light.

the distance, so too does definition, detail, tone and colour. Remember that when setting out to portray a landscape, there will always be something moving. Even on a stiflingly hot day, a heat haze can fracture and distort the distance. Obviously wilder weather stimulates greater action, so use your imagination and what you have learned here to try to convey the feeling and mood of this movement.

▲ The falls by Kildonan

WILLIAM GARFIT, OILS

The strong tonal contrast between the rocks and the foaming water, and the lively brushwork describe the cascade within the peaceful Scottish landscape. The whiteness of the spray also contrasts with the calm, cobalt blue flow above the falls. The brushwork used for the churning water is accentuated by the smoother grassy bank and distant, muted hills.

EXERCISES

Sky is highly influential in creating the appropriate mood in a picture, and its character, colour and tone must correspond with, and will often effectively emphasize, the action. To portray a rugged, wind-swept landscape or violently raging seas with a cloudless blue sky would not make sense. Try to look at skies as an element that you can use to enhance, liven and accentuate the action in the scene. A variety of techniques can be used to create different moods and degrees of movement in the sky, from calm to turbulent.

Lifting out clouds from a wash

1 *Working onto wetted paper, paint a fluid wash in antwerp blue, letting it gradually fade towards the bottom.*

2 *While still damp, use a loosely scrunched-up tissue to lift out the tops of the cloud shapes.*

3 *Working down the paper with the same piece of tissue, continue lifting out to create the voluminous cloud formation.*

4 *The edges of the clouds will gradually soften as you move down the paper, making the sky recede away as it approaches the horizon.*

Lifting out clouds from a double wash

1 *Lay a wash that begins with yellow ochre and fades into light red towards the bottom. Overlay a second wash in payne's grey.*

2 *Working fast onto the still-damp paper, lift out the cloud shapes with a tissue.*

3 *Dabbing with dry patches of tissue each time, lift out the curving line of more sharply defined clouds sweeping up into the darker area of wash. The tonal transition in the wash from darker at the top to paler towards the horizon creates a sense of the scene moving back in space.*

Blending the cloud colours

1 *Working onto wet paper, lay down a weak ochre wash and overlay this with stripes of antwerp blue. Into this, dribble payne's grey.*

2 *Add light red into the payne's grey, and as the colours merge, soften and blend the edges by lifting out with a tissue.*

3 *Once the sky has dried, use a darker wash of payne's grey and light red to put in the hills in the distance. The graduated tones of cloud in the sky draw the eye across them down to the horizon.*

Variegated lifting out from a double wash

1 *Lay a graduated pink wash. When it is dry, turn the board upside-down and overlay it with a wash of antwerp blue.*

2 *Working fast into the still-wet paper, lift out the puffy clouds with a loosely scrunched tissue. The diagonal arrangement suggests that they are being blown across the sky.*

Lift out some areas of the blue wash more firmly than others to suggest that the clouds are dissipating as they break away from the mass on the horizon.

Blending clouds out of a wash

1 *Lay a lemon yellow wash, and add loosely painted patches of antwerp blue into it. Add payne's grey and let it diffuse into the blue and yellow.*

2 *Squeeze out the brush and gently blend the bleeding areas of blue and grey to soften the edges.*

Put in the dark horizon line. The lemon yellow above it forms the focal point, and lends a depth and surging uplift to the wind-whipped clouds.

Responding to the elements

The aim here is to show figures struggling against the elements, and the way in which these elements affect the people and the surrounding landscape. Oil paint is used to build up layers of colour, sometimes obliterating the figures in the process, and then re-stating them in order to convey the direction of movement and a sensation of depth and atmosphere.

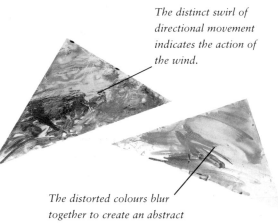

The distinct swirl of directional movement indicates the action of the wind.

The distorted colours blur together to create an abstract image with the direction of the wind movement.

Materials used

Primed canvas
●
Oil paints
●
Sable and bristle brushes
●
White spirit
●
Rag

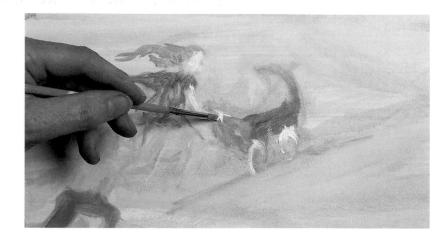

1 *Lay a ground wash over the primed canvas using dilute yellow ochre. Then, drawing with a slightly thicker ground colour and lifting out with a rag, sketch in the basic shapes of the composition. Using cadmium red diluted to an almost watercolour-like consistency, paint in the figures and add titanium white for the highlights.*

2 *Turn the canvas upside down and drag a cobalt blue wash across it, allowing gravity to draw the wash evenly down the canvas.*

3 *Take the canvas off the easel, and prop it up on its side. Again using the force of gravity, dribble cerulean blue down the canvas to create the impression of the strong, horizontal-driving wind.*

4 Lie the canvas flat on the floor and use a rag to smudge the directional dribbles.

5 Build up the landscape with another layer of dilute oil paint, letting the figures become virtually obliterated.

6 Reinstate the figures with firm impasto strokes. Using thicker paint, make large, directional sweeps across the canvas following the pull of the wind. Use smaller brushmarks to pick out details and the lighter focal point on the horizon.

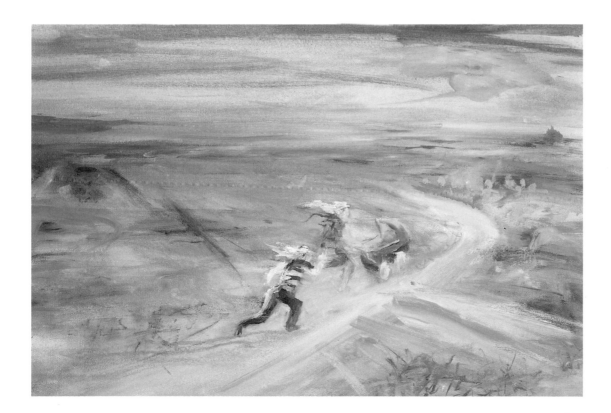

◀ **Rainstorm**
ANTHONY TUFFIN
The streaming hair of the figures emphasizes the strong directional force of the wind. The blustery effects of the wind are described through the sweeping brushwork and the unusual technique of building up layers of dribbled washes.

PROJECT 13

Colour contrasts and directional brushstrokes

Movement in landscape can be seen, and portrayed, through the way that features are affected by the elements. Wind, rain and snow all act on trees, bushes, hedges and grasses, distorting their shapes and causing them to adopt new lights and darks, and colours and moods. A variety of brushwork techniques and colour contrasts are used in this project to depict this dramatic movement. Directional brushstrokes, in particular, can convey the feeling of a strong wind convincingly.

Even when you are using a photograph for reference, allow your imagination to distort shapes and forms.

Materials used

Canvas
•
Acrylics paints
•
Sable and bristle brushes
•
Charcoal

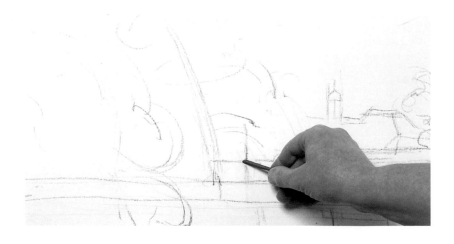

1 *Map the composition directly onto the canvas with charcoal.*

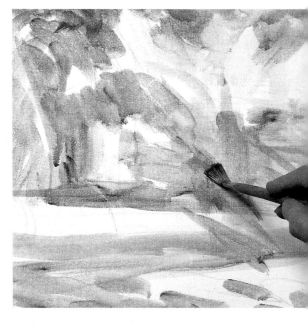

2 *With very diluted, watercolour-like, acrylics and a wide, square-ended brush, block in the different areas of the composition.*

3 *With thicker paint and a larger brush, scumble dark indigo over the preliminary wash in the sky.*

4 *Holding the brush at half-mast, use short, directional strokes of rich, thick paint to describe the wind pulling the trees in the distance.*

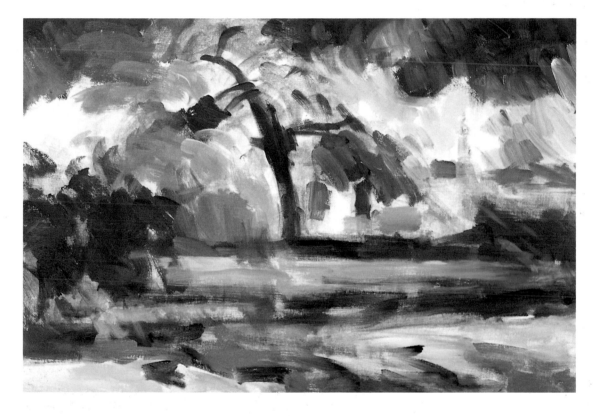

5 *Work over the rest of the original wash with robust strokes of thick acrylic. This gestural brushwork should lay the foundations for the strong, vibrant colour and motion of the gusting wind.*

6 *Keep the direction of the brushstrokes consistent. A smaller brush can be used to add the highlights in the foreground trees.*

7 *Angling the brush and holding it at arm's length, make contrasting, directional, mid-toned strokes to add depth to the sky and express the forceful pitch of the rain.*

8 *With a rich green impasto, use elliptical brushstrokes to enhance the richness of the colour in the tree and emphasize its voluminous form.*

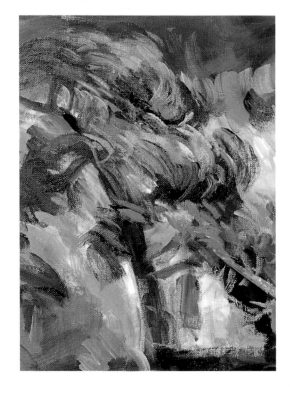

9 *Add streaks of cobalt blue across the foreground, which contrast with the autumnal gold leaves and force the eye towards the stormy, sunlit areas.*

10 *Working over dry paint, put in the highlighted branches and trunk of the foreground tree, which immediately becomes the focal point of the painting.*

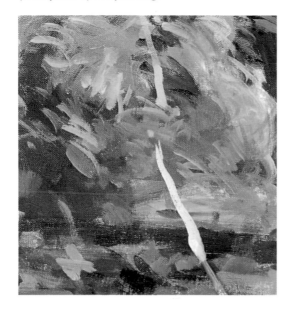

11 *Finally, paint in the pale, sunlit branches with a small brush.*

▼ Blustery day

TED GOULD

The power of the wind is suggested through the juxtaposition of vibrant and contrasting colours, and through the sweeping gestural brushwork. The trees have become very distorted in shape as they succumb to the force of the wind.

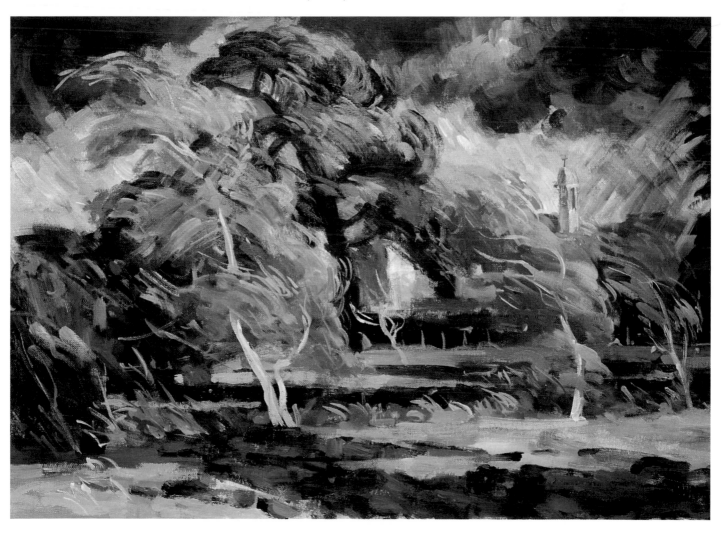

Movement & seascape

Moving water is perhaps the most challenging subject for any artist. Unlike landscape, the sea is in continual motion and can behave with a mind and character of its own. On a calm day the surging of the waves possess a rhythmic, almost hypnotic quality, with their rise and swell. In dramatic contrast, a wild, angry havoc of a storm, with heavy seas rising and fighting in reckless abandon, can inspire an intoxicating reaction. For the artist, the mood of the sea is an irresistible draw – its spirit of ceaseless motion has to be captured by your chosen medium.

◀ **Round the Island Race 1992**

JACQUIE TURNER, OILS

In this loose, impressionistic painting, the busy movement of boats in the sea takes on an almost abstract quality. The iron-blue, washed-in tones convey a damp atmosphere and describe the character of the undulating sea. Contrasting, lively squiggles of colour suggesting the reflected shapes of the boats convey continual motion.

The natural power of the sea is a force that involves and ensnares everything in its way. It commands a respect. Although the sea may appear solid, we know it is perpetually moving, and expressing this presents an artistic challenge. The sky also plays a role, and its mood is reflected and intensified in the sea. The artist needs to describe the momentous rhythm of the waves and the wind-blown sky as an all-encompassing whole, without too much attention to detail. Although it is tempting, and quite easy, to portray thick clouds and a heavy sea by concentrating on a detailed representation, this will create a static, moodless image.

Observation

Notice how water patterns break, and where the light irregularity hits the surface to impart a transient feeling to the water. The

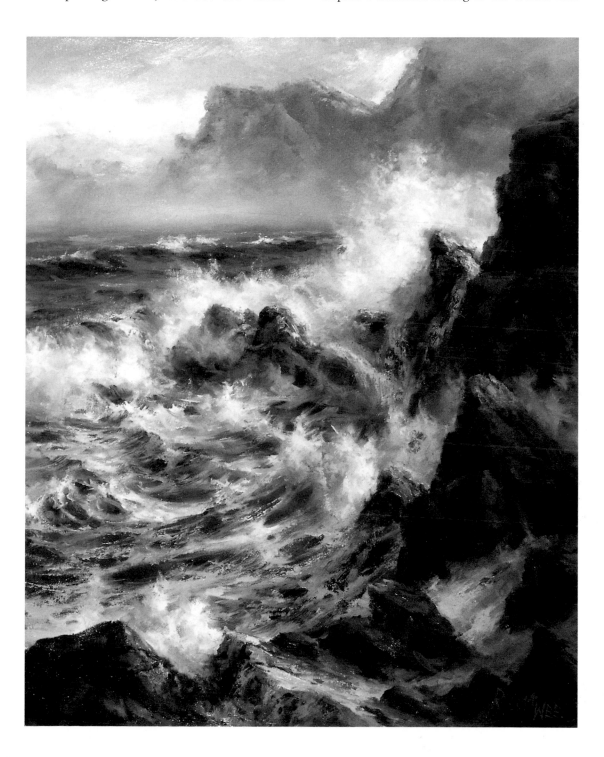

◄ **Foaming thunder**

ROBERT WEE, OILS
The sea's natural force and power is strongly expressed here. The perpetually moving mass crashing against the solid rocks is evident in the rebounding spray. The artist has captured the driving swell through sweeping, directional brushstrokes of interchanging colours. The wild spray, depicted with a frenzy of irregular, flicking strokes, absorbs shadow and highlight, giving an impression of incessant movement.

pattern over the surface invigorates the image. Take a look at the Impressionists and how they achieved the illusion of running water. Georges Seurat chose to recreate the water surface with a series of dots and strokes. His painstaking work and detailed observation enlivens the water with a kaleidoscope of colour, light and sparkle. Claude Monet, who heralded the Impressionist movement with his *Impression Sunrise* (1872), used a seemingly random but, in fact, carefully calculated selection of swift brushstrokes and tonal patterns to mimic the reflections over the water. The unexpected distortion of colours and shapes, punctuated by the dancing light, seem to laugh at the solid ground.

Try to adopt this approach when looking at the sea. What shapes and patterns do you see? Have they become simplified shapes of colour, or areas of highlight? The surface of moving water is most easily analysed and portrayed as an abstract pattern that, in context, can be fantastically evocative.

The point where the sea hits the land with a repetitive rolling wave surging up the beach can present a problem to an artist. How do you convey something full of motion coinciding with the motionless? How do you convey the permanence of the beach

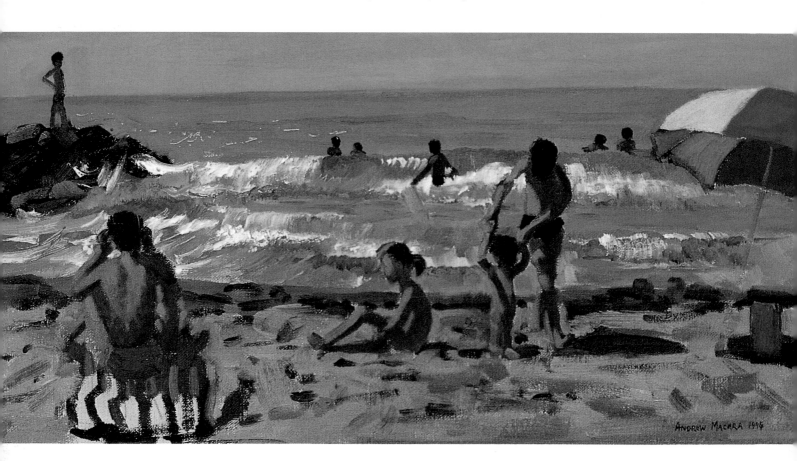

▲ The lookout, Cap d'Adde

ANDREW MACARA, OILS

The artist has followed the direction of each stage of the rolling waves with the brush, accentuating the curling top of the wave, the splashed surf and the more evenly undulating sea in the distance. The sensation of movement is increased by the contrast with the flatter treatment of the beach and figures.

◄ The sea

HAZEL FARRELL,
PASTELS
The detailed patterning of the sea's surface and the irregular shapes of the rolling surf create a wonderful feeling of space, distance and oscillating motion. Where the smooth sand contrasts with the zigzagging line of surf, the viewer anticipates the wave breaking onto the beach.

► Restless

LAVERE HUTCHINGS,
WATERCOLOURS
This watercolour conveys a momentary impression, with the form of the rock disappearing into the cloak of spray. By working wet into wet, the artist suggests a subtle illusion of moving, hazy spray. The sense of distance created by allowing the sea to decrease gradually in hue and detail accentuates the captured movement.

▲ Passing storm

F. CAMERON-STREET,
PASTELS

*The dark, menacing
colours of the storm
are reflected and
embodied in the
surface of the sea.
The crashing spray
adopts the ochre
light of the clear
sky. The distant
island mirrors the
heaviness of the
clouds, creating an
impression of depth
and intensifying the
atmospheric
movement.*

with the ever-interchanging colours, weight
and endlessness of the sea? Try looking for
the differences in form, shape, texture and
tone between what is in motion and what is
motionless. Where the two meet, the beach is
gobbled up, its image fractured and broken
beneath the surface of the untamed water.

Rhythm and pattern of the sea

As you watch the surface of the sea, you will
notice that it is broken up into repetitive
shapes and patterns. Undulating "half
moons" form randomly, catching the light
and falling into shadow as they pursue a
diminishing course towards the horizon. At a
glance, the colour of the sea appears to
reflect the sky, absorbing its vaporous
colour, reinforcing its intensity in pewter
grey, indigo, cobalt or translucent turquoise.
You will notice, too, that these colours
change in the shallows, picking up the

reflection of the sand, pebbles or mud
beneath. The sea's tonal change indicates its
depth, introducing a dimension of distance.
The dazzling white sand of the Caribbean,
together with the brilliant azure skies,
enhance the sea with an exotic turquoise.
However, around the shores of a pebbly or
ochre sand beach, the shallows appear a dull
viridian or an anaemic indigo.

A variety of techniques may be used to
suggest the rhythmical movement of the sea.
Repetitive linear brushstrokes can depict the
continual motion, leading our eye over the
movement again and again. These strokes
imitate the fluid rise, fall, crash and roll of
the waves on the beach. Further out to sea,
beyond the breaking waves, the surface
settles into patterns of dissipating ripples.
These have a timing of their own, casting
myriad highlights and shadows. Look at the
ripples and try to match their rhythm as you
plant each brushstroke. The surface mass

will soon become infused with atmosphere from these interspersed dips and twists of colour and highlight.

Reaction to the sea

It is hard to set a seascape into scale without any comparative landmark or feature. Try to include a person, pier, boat or cliff to lend a sense of proportion against which to measure the vastness of the sea. Otherwise the waves may appear big and ferocious, but how big? The way in which people, boats or wildlife react to the sea implies the strength of its movement. A child running up the beach to escape a breaking wave suggests that it is coming in fast. An ebb tide swooshing past a moored boat, pulling its rope so taut that its buoy is raised diagonally out of the water, powerfully suggests the directional force of the current. The force of the waves can be judged by the height of the spray against the wooden pierhead.

It is impossible to discuss emotive seascapes without mentioning the nineteenth-century artist, J. W. Turner. The energy,

▼ Round the Island Race 1994

JACQUIE TURNER, ACRYLICS

Broken colour in the sea is used to indicate the choppiness of the water. The impressionistic muddle of sails on the horizon is reflected over the rough surface with short, thick brushwork. The boats' reaction to the lumpy sea and gusty wind conjures up the illusion of movement.

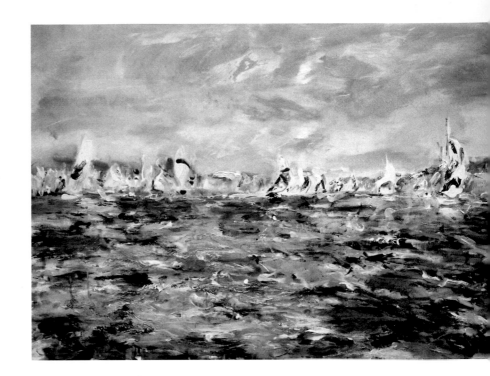

▶ Freshening breeze

CONSTANCE HALFORD-THOMPSON, PASTELS

The merging of the sails into the sky, and of the boat into the heavy swell, together with the inclusion of the absolute minimum of detail in the boat itself and the crew, evokes a dramatic impression of movement through the water.

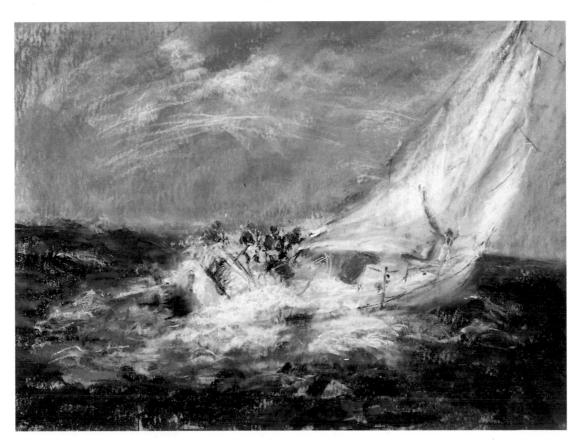

velocity and power of turmoil created in his paintings are an inspiration. He imbues terrific atmosphere and mood through his emotional brushwork and palette. The all-encompassing sky causes us to lose sight of the horizon; we are overwhelmed by the intensity of the scene. Towards the end of his life his work verged towards the abstract, with definition becoming immaterial to the realization of the subject. Through his work we learn that sky and sea are inseparable in seascapes – the two are one.

Changing the viewpoint

The atmosphere of the sea and its alternating patterns differs greatly, depending upon the point from which you view it. If your view includes the beach, looking out to sea, you notice how the water varies in colour as it moves away from the shallows towards the horizon. When you are painting a section of beach in the foreground, it can be tricky to

suggest that it is sloping away from you down to the water's edge. A few figures placed randomly between the top of the beach and the water's edge can make the illusion more convincing. Use the relative positions and sizes of the figures to suggest the steepness of the beach.

By shifting the focal point out to sea, perhaps to a boat in the distance, however, you can avoid this problem. Place the horizon low, so that the sky dominates the picture, and record the sea through the patterns formed on the surface.

A moving seascape exudes spirit – whether melancholic, threatening or exuberant. If the heavy mass of sea is enlivened with charismatic brushwork, you will have communicated its spirit with vibrance.

▼ **Biscay rising**

HAZEL SOAN,
WATERCOLOURS
The strong use of colour, light and shape produce an almost graphic illusion of dynamic movement of the sea. The drifting, swirling sky, painted with wet-into-wet washes, suggests the approaching storm. Contrasted with this, the dominant, hard-edged, near-abstract shapes in the sea suggest its enormous power.

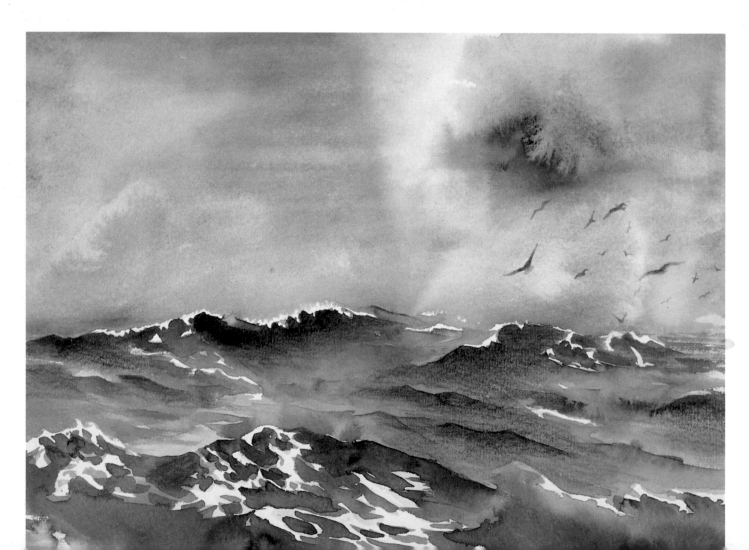

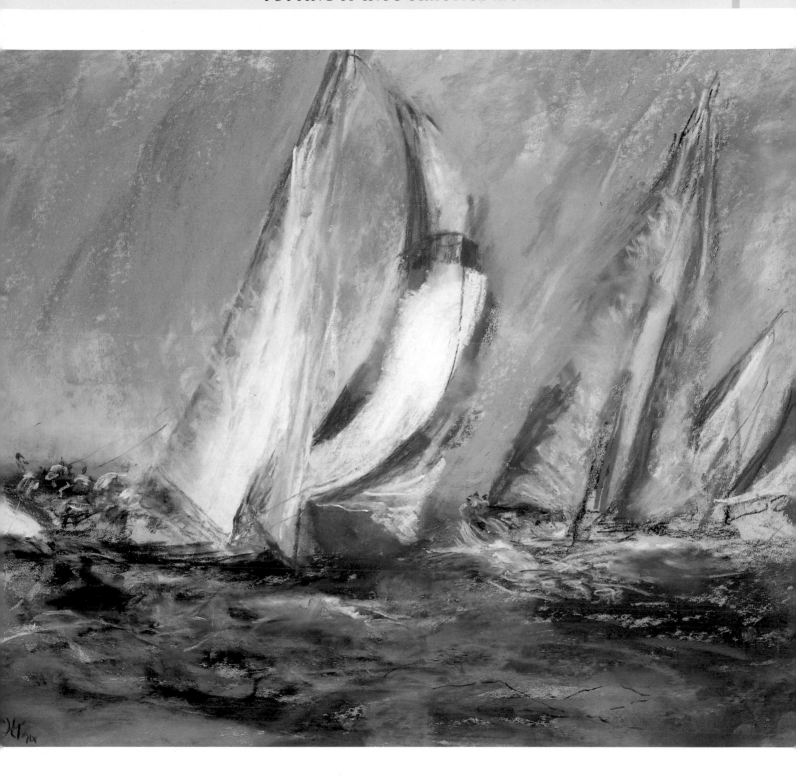

▲ **Fair breeze**

CONSTANCE HALFORD-THOMPSON, PASTELS

Masterful use of colour and a lack of detail create the atmosphere of perpetual motion. Attention is drawn to the frantic activity in the foreground, depicted by more linear areas. The increasingly rich hues towards the horizon suggest the depth and feeling of space. The blurred, faded edges of the sails, spray and horizon line accentuate the image of motion.

The sea is in a constant state of motion, as the waves swell, rise up and break and as the water rolls in towards or pulls back from the shore. This backwards-and-forwards motion has a strong directional quality, and you can evoke this with directional brush-strokes and lines that follow the push and pull of the water. Contrasts of tone and colour can also be used to accentuate and give form to the crests and troughs of the waves.

▼ Tidal pull

The sea, being a constantly moving, heavy mass, can trigger ricochet movements from the things it comes in contact with – boats on the surface, people swimming, or objects carried on the rolling waves. Its undulating, rhythmic motion has a directional pull, which is always greater on an ebbing or incoming tide. Depending on its location and condition, the tide can be ferociously strong, unrelenting and often dangerous. Here, the tremendous directional force of the ebbing tide is described by the way in which the boat helplessly succumbs to its incessant pull. The tautness of the ramrod straight lines is exaggerated by the outward lean of the mooring posts and the arching curve of the boat's stern. The sombre glows and converging, streaked directional strokes of the sea and hills beyond, intensify the nagging tug of the tide in this triangular composition.

The angle of the mooring rope, being the only opposing diagonal within the picture, creates a jarring note.

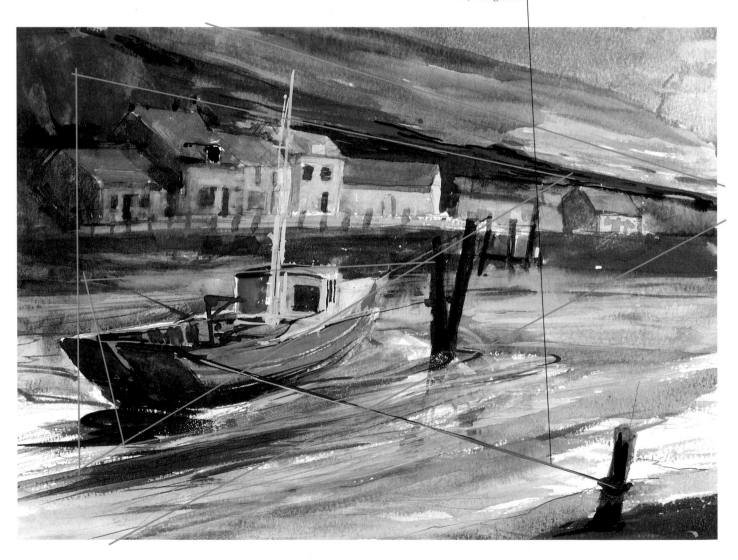

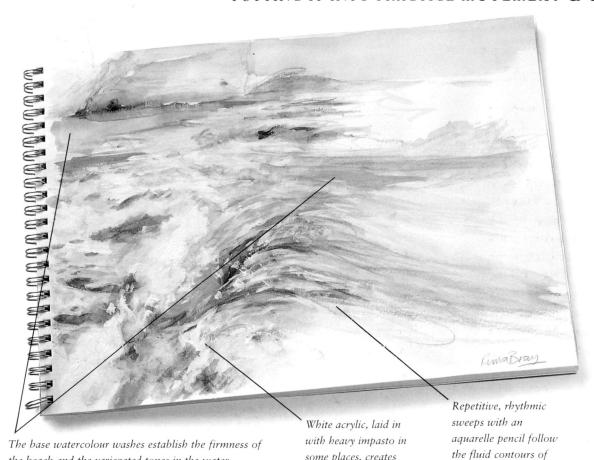

◀ Undulating surface

The sea consists of a rhythmically undulating and constantly moving mass of water. In this exercise a combination of mediums are used to describe the ceaseless effect of rising and crashing waves, the flying spray and the transient surface effects.

The base watercolour washes establish the firmness of the beach and the variegated tones in the water.

White acrylic, laid in with heavy impasto in some places, creates the vaporous sensation of kicked-up spray.

Repetitive, rhythmic sweeps with an aquarelle pencil follow the fluid contours of the rolling waves.

▶ Highlights and shadows

The rising and rolling curve of the wave is portrayed with a dark, dense indigo that contrasts with the whiteness of the effervescent surf. A dynamic impression of charged movement is achieved through stark colour contrasts, brisk directional brushstrokes and translucent overlays of milky-white spray to distort the detail.

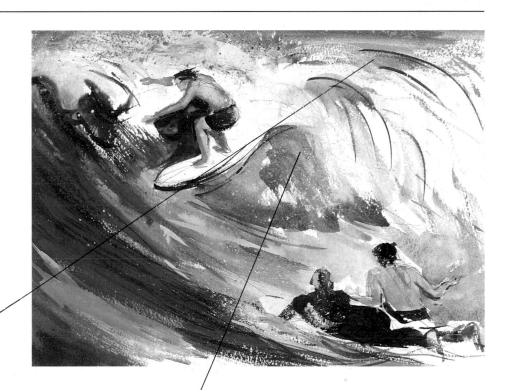

Short, sweeping strokes with a small brush map out the forms of the moving wave.

Milky strokes of white gouache are laid over the denser blues to emphasize the plunging action of the brilliant surf.

PROJECT 14

Moving through water

The aim of this project is to convey the chaotic motion of the sea and wind through the pitch and action of the yachts, which yield to the wind's force, while using it to propel themselves over the heavily undulating surface of the water. The use of thick acrylic paint applied with a palette knife and sweeping brushstrokes effectively describes this motion.

The voluminous tilt of the wind-filled sails contrasts clearly with the directional surge of the sea.

Materials used

500g/m² (240lb) watercolour paper

•

Watercolour paints

•

Conté hard pastel

•

Acrylic paints

•

Sable and bristle brushes

•

Palette knife

•

Kitchen roll

1 *Lay a thin base ground of alizarin crimson and yellow ochre acrylic, and then map out the composition in watercolour using a stronger mix of alizarin crimson.*

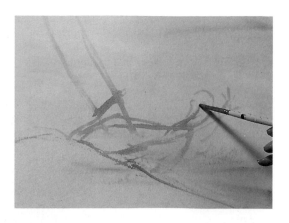

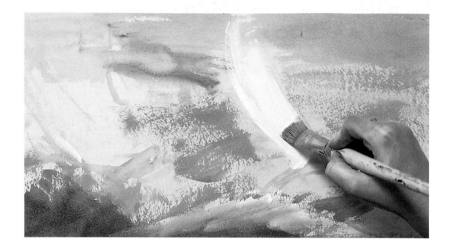

2 *Using a wide brush, establish the sea colour with sweeping strokes of prussian blue and permanent green acrylic. They should follow the directional surge of the waves. Block in the main colours of the sky. Use broad gestures of titanium white to describe the sails and surf, and yellow ochre for the hull of the nearer yacht.*

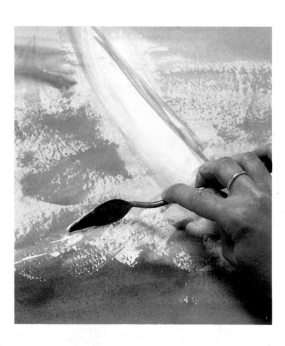

3 *Gradually incorporate more detail. Pick out the mast loosely with a dilute mixture of prussian blue and permanent green acrylic. Use a palette knife to add texture to the sail and streaks in the angled spray in titanium white. Add in the figures with broad brushstrokes.*

4 Watercolour washes used in combination with acrylics introduce a fresh, translucent quality to the sea.

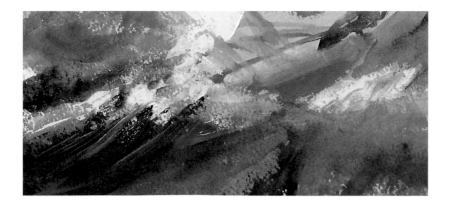

5 Use a finger to smudge the figures so that they don't stand out sharply.

6 Using a broad brush, suggest the sails in the distance. With a palette knife and thick acrylic paint, lay in the characteristic wild spray over the dry paint, and spread pale cerulean blue along the horizon to create a feeling of depth.

7 Use a piece of kitchen roll to knock back the sails in the distance. Then pick out the necessary detail with small acrylic brushwork and conté hard pastel.

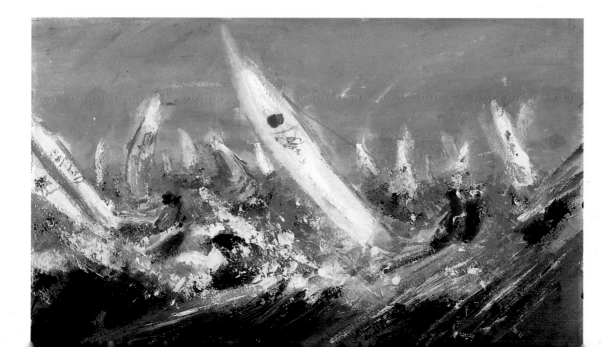

◀ **Yacht race**
RIMA BRAY
The intoxicating spirit of the sea is captured in motion by the buoyancy and balance of the yachts. The immediacy of the sweeping, vibrant brushwork and palette knife keeps the image fresh and alive.

Movement & objects

If you choose to portray the moving object, you are bound by the physical rules of action and reaction. One movement derives directly from a prior movement – and this movement may come from another source entirely. A football kicked high in the air or a bicycle pedalled down a street are objects which have been forced into motion by the action of another. A machine – like a car or a train – can reach enormous speeds but have no obvious source of motion. To express such movement with conviction, the artist must convey the functioning reality of the machine or object while in motion.

T he action of people, creatures and the elements all play their part in causing reactions. Every movement always has two players – the actor and the acted upon. When a horse pulls a cart, the final result is a forward motion. The artist must provide a convincing image of this resulting movement.

The sea and weather possess immense power and influence over the movements of objects. Washing pegged on a line flaps defencelessly. In other situations, external elements are controlled and coerced into producing the desired motion. Wind can be caught and controlled in the full sail of a dinghy on the sea, and used to propel it over the water. Man-made motivators may be harder to infuse with a sense of speed. Though cars and trains transport us far more

◀ **Puddle jumper**
DENISE BURNS, OILS
The broken reflections together with the bow waves indicate that the tricycle is moving through the puddle. However, the reasonable sharpness of the image suggests that the child is not going very fast.

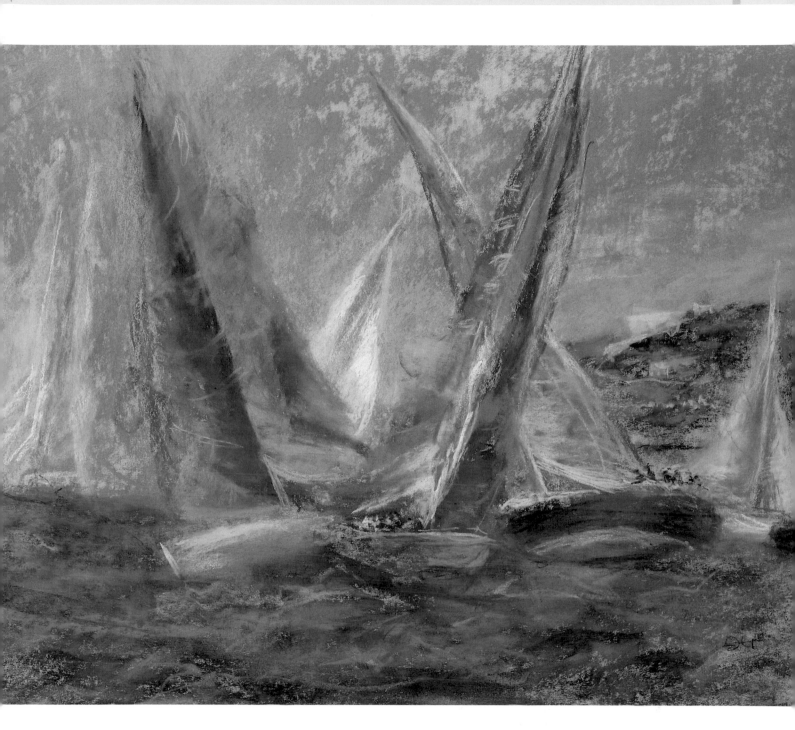

▲ Jostling for position

CONSTANCE HALFORD-THOMPSON, PASTELS

The shape and balance of the boats describe their reaction to the wind and undulating sea. The wonderful arc of the listing hulls and the tall, concave, wind-filled sails accentuate the impression of jostling movement.

quickly and efficiently from A to B than when we were dependent on the forces of nature, the lack of obvious motivation from outside can result in a rather sterile, unimpressive depiction.

Observation

To suggest movement in your object, it is a question of knowing which elements will imply the greatest sense of action. It is generally understood that objects tend to

lose their definition during rapid movement; what we are left with is an *impression* of speed. Inanimate objects, when not acted upon by an outside force, are completely stationary. This gives the artist great opportunities for detailed observation from every angle. Look at a bicycle: it is a relatively simple construction, with challenging aesthetic combinations of circular and angular shapes. Note the proportions, the level of the pedals, the position of the seat in relation to the handle-bars, and where the wheel shafts meet the axle. Now, apply what you have learned to a moving bicycle. See how the pedals rotate and the wheel spokes spin into a blur. By exaggerating the foreshortening as the bicycle comes towards you, or the angle of cycle and its cyclist pedalling around a corner, you will impress a greater sense of energy on the motion. In the painting, it is essential that the cyclist's action relates to the perceived speed of the bicycle, so that they appear to work in conjunction,

generating a convincing sensation of swiftness. Light, shadow, colour and tone will further emphasize the movement.

If a particular terrain or pitch of ground causes the object to move, try to include it to contribute to the reality. Otherwise your picture relays the climax of the story without benefit of a plot. A ball rolling down a hill gathers in momentum until it rolls past you. If you were to change your viewpoint, placing yourself at the top or bottom of the hill, you would have a problem. How would you portray the pitch of the slope and achieve the illusion of the ball actually rolling? You would effectively be restricting

▼ **Streamers**

NEIL DREVITSON, PASTELS

The action here appears frozen in a moment of time. As every element is so highly focused, the scene seems almost surreal. However, it shows how detailed observation can record the accuracy of the new shapes, shadows and tones in movement.

▶ **Okavango Swamps – the landrover**

Hazel Soan, watercolours

The impact of the action is described through the kicked-up spray of water. The directional shaped highlights, suspended radially over the shaded tones, describe the violent reaction of the water. Contrasted with the horizontal washes of flatter water, the impact of the vehicle's motion is dramatically emphasized.

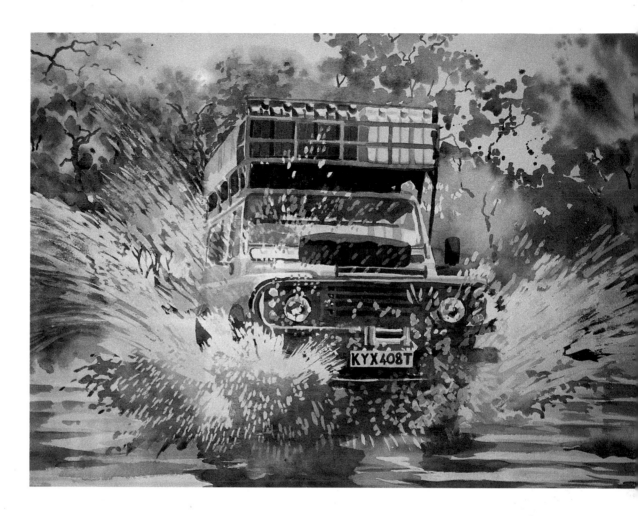

your observation and, at the same time, losing the best perspective to capture the drama of the action.

If you depict a sailing boat racing across the water in high wind, remember that all elements of your picture will be in motion. We explored the part the sea plays in the previous chapter. With the combination of sea and wind, the boat will be the only solid structure within your picture. With sails full and hull keeling, the boat yields to the wind and submits to the motion of the sea while aggressively carving its course. If the sails were shown flapping loosely on an upright boat, the spectacular energy of wind and sea would be lost and the picture devoid of all interacting movement.

Machines in motion

Motorbikes, cars or trains do not change in physical appearance in any way when motivated. A car does not contort itself into elongated or expansive shapes, or produce clouds of billowing smoke with accompanying skid marks, as in a cartoon. To produce an authentic image you must notice what is affected by its movement. On a dusty road a cloud of dust will map its wake. The centrifugal "rush" will force the grasses and vegetation lining the edge of the road to bend and bow. A deliberate lack of detail on the car itself will emphasize the feeling of motion, but the minimum necessary definition, tone and shadow must be included to identify it. Notice how the streaking taillights of vehicles at night form ribbons of orange and reds, with the dark shape of the cars themselves practically swallowed by the blackness of the night. Try adapting this new perception to your portrayal of a car in daylight. Replace the streaking lights with highlights to express the directional motion. As machines are capable of great speed, the artist has to use tricks to create the illusion of haste and maximize the overall impression.

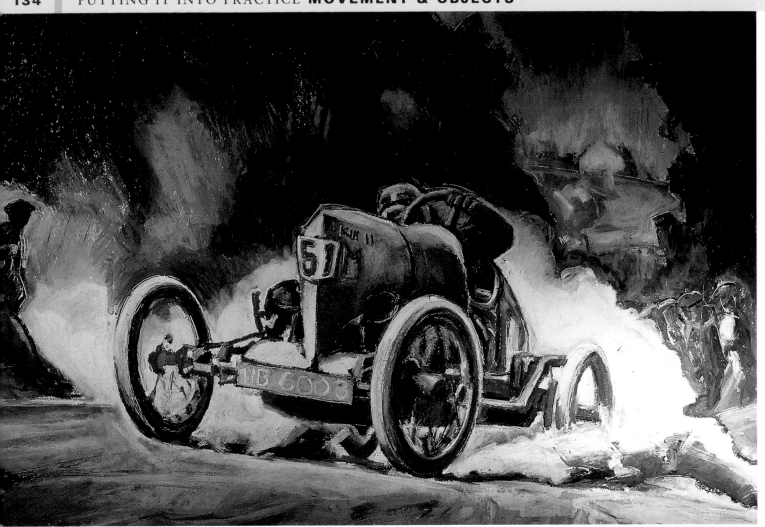

▲ Kim II. Climbing Shelsey Walsh Hill c.1921

JOHN TOWNEND, MIXED MEDIA

Greater impetus to the motion has been given through the humorous extension of reality, both in colour and viewpoint. From the low viewpoint, the approaching car looms even larger, and rapidly diminishes in a trail of dust that exaggerates the impact. The whiteness of the dust and the contrasting greenery effectively propel the car forward.

▶ Traffic jam

HAZEL SOAN, WATERCOLOURS

Instead of using perspective to emphasize the action, here it captures the overall impression. The focused shapes of the vehicles suggest slow movement.

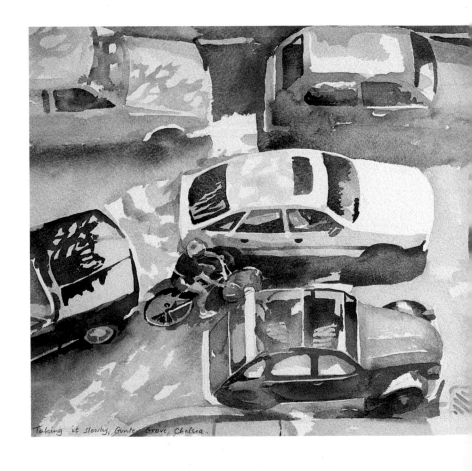

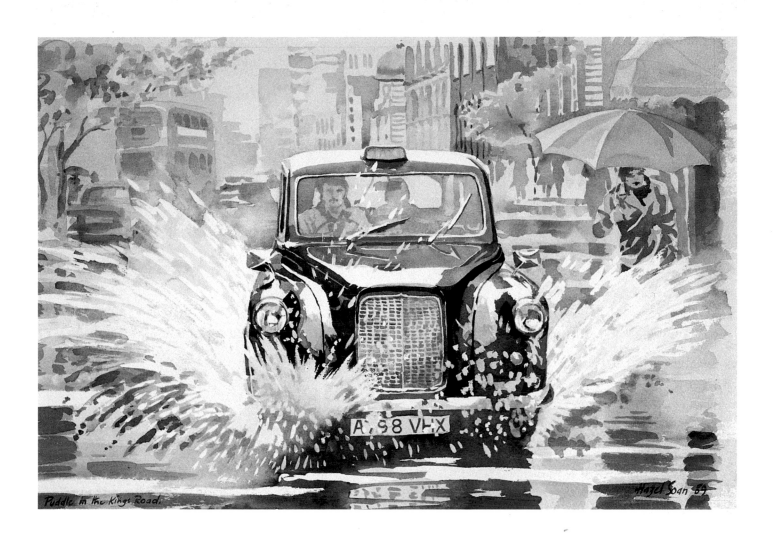

Puddle in the King's Road.

Hazel Soan '89

▲ **Taxi in the King's Road**

Hazel Soan, watercolours

The strong shape of the taxi against the less distinct background shapes, together with the sprays of water on either side and the loss of detail around the bottom of the taxi, all combine to indicate that it is moving.

Hazel Soan '89

Treatment and technique

As we have seen, there are a whole selection of techniques which allow the artist to achieve the impressions of movement and effects of speed. The translucent nature of watercolour allows the artist to develop mood in the shadows, and leave selected areas unpainted to achieve dramatic highlights. Imagine a racing car coming diagonally towards you. The wheels, part of the headlights, the fender, the shape of the bonnet and windscreen are all you need to recognize the speeding car. With the rest of the bodywork left unpainted, with perhaps a vague hint of the running board and rear wheel, the image would portray a car moving at high speed.

Pastel offers different qualities, but also utilizes the lack of definition to suggest motion. Its characteristic texture can be used to capture the subject with minimum detail and focus. This, combined with techniques

◀ Barge

GEOFF MARSTERS, PASTELS

The subtle use of tone successfully conveys the impression of movement, while the near upright mast, even keel and completed outlined sail shape indicate that the pace of movement is slow. The whole scene is bathed in an even, misty light that saturates the sails and sea, enhancing the atmosphere and gently inspiring the feeling of motion.

▶ Football

ANDREW MACARA, OILS

The contorted and related shapes of human action relay the movement of the ball: the boy's action would not make sense without the ball being positioned in mid-air. The light causes the elongated shadows to reflect the action and magnify the ball's flight.

such as blending, smudging and blocking, enables the artist to capitalize on its versatility to produce a dramatic impression of movement.

With oils, the highlights, shadows, detailed and undetailed areas are all part of the paintwork. In contrast to watercolour and pastel, where the artist utilizes the bare paper to achieve the tones and highlights, oils allow everything to be incorporated on the canvas. By inspired use of brushwork, the artist can capture the elemental power of

movement by blurring colours into a rich, frenzied impasto to impart vigour and energy to the action. Irregular dots and dashes of colour stimulate the illusion of power and speed. Last, but not least, remember that the impression of things moving at high speed should be presented as if seen at a glance, through loose brushwork, lack of detail, and only the identifying features rendered distinctly.

▶ **The belles of St Martins**

OLWEN TARRANT, OILS

The exaggerated perspective and the stretching figures combine to create the impact of movement, while the ball poised over the goal forms the focal point of the action. Notice how the triangular shape of the composition influences the sensation of movement.

The way in which inanimate objects move often depends on the material from which they are made. A soft object, such as a flag or washing on a line blown by the wind, responds by changing shape in constantly undulating motion. Rigid objects, on the other hand, such as the train and bicycles opposite, display movement more subtly. Without the flexibility of softer materials, the clue to their movement must be sought elsewhere – in the puff of smoke trailing back from the engine, or the streaky shadows accentuating the forward rolling of bicycle wheels.

Interactive movement

Objects move because they are made to by an external force, by a person such as a juggler and a puppet-handler. In this type of subject it is important that facial expression, posture and hand movements synchronize if the sense of action is to be convincing, and that the juggler's and puppet-handler's reactions support it.

▶ *The puppet handler's posture reflects the movement of the puppets, from the incline of her torso to the stretched arm and angle of her wrists. The controlling tilt of the strings implies the puppets' action, which is further magnified by their dark shadows.*

◀ *As the puppet-handler bends forward with an extended arm, releasing the tension on the left-hand puppet, it assumes a static, lifeless pose while the other remains lively and animated.*

▼ *The details of the hands illustrate the way in which an object's movement is controlled and directed.*

▶ *The open-mouthed concentration and locked gaze indicate the captured moment of the action. The raised hand and the tops of the balls lack definition, which exaggerates the caught instant and the pace of the balls as they are tossed alternately into the air.*

▲ *The juggler is balanced on the balls of his feet, with his eyes intently focused on the ball, suggesting a sense of immediacy. Only the top edge of the upward-flying ball is defined, while its shape is elongated to accentuate the movement.*

▼ Visual clues

When an object moves, its action is sometimes signified by a reaction. In David Prentice's Mountain Railway, *the movement of the train is given away by its upright column of smoke. The illusion of motion is emphasized by highlighting the mountainous landscape with vivid, angular, linear strokes made with the side of the pastel stick. The road surrounding the lake, and the directional blocking-in tones of green, olives and yellows, all converge at the train, lending greater impact to its movement.*

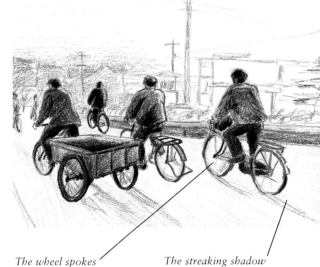

The wheel spokes become more blurred the faster the wheels rotate.

The streaking shadow lines emphasize the forward direction of the movement.

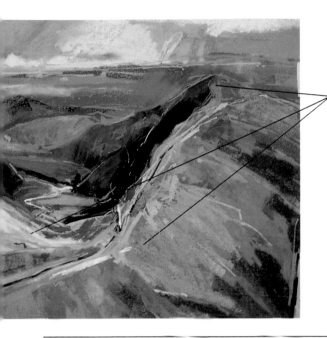

The linear pastel work imitates the directional motion of the train.

▲ External forces

A moving object is usually stimulated into action by someone or something else. In this case, the bicycles are activated by their riders. It is important that the posture, shape and action of the cyclists relate to the movement and pace of the bicycles. In this pastel sketch, the twisting shift of weight and balance of the hindmost cyclist is on the downward pedal to express the energy and power of the motion.

▶ Undulating motion

Shape can be used to indicate movement. For example, objects caught in the wind are altered in shape and physical appearance. A flag laid out flat is rectangular in shape, but suspended on a flag-pole on a still day it becomes a limp form that hangs down the length of the flag-pole. When caught by the wind, the flag becomes animated and yields uncontrollably to the forces buffeting it. The constantly changing shapes express the action. In this sequence, the shapes suggest a gust of wind blowing, then dying.

The pace of the wind slows, causing the flag to ripple and undulate, rather than being fully extended.

Finally, the wind dies, and the flag flops gently while still maintaining its curvaceous form.

Changing direction, the wind swirls upwards, indicated by the curling curve at the end of the flag.

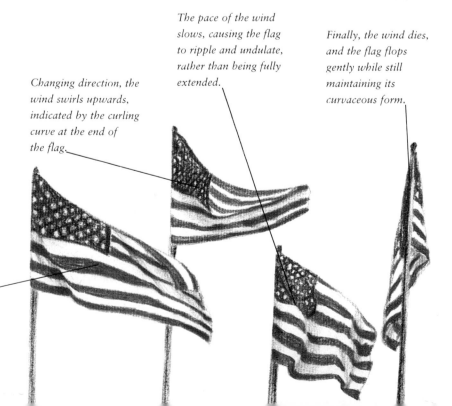

The gust of wind is strong, stretching and pulling the flag out and away from the flag-pole.

Varying the focus

An object does not necessarily alter its physical appearance as it moves, unlike trees, figures, animals or the sea and this can make the task of conveying a convincing impression of movement far more tricky. Consequently, composition, brushwork and colour become vital in creating a feasible and evocative image.

The composition is based on a collage of photographs. The ellipses forming the top and bottom of the carousel contribute strongly to the three-dimensional circular motion.

Materials used

600g/m² (300lb) watercolour paper

•

Oil pastels and oil bars

•

Acrylic paints

•

Rag

•

Palette knife

•

2B pencil

1 *Prime the watercolour paper with white acrylic paint to form a tough base to support the oil colour. Sketch in the composition with a sepia oil bar, and then begin blocking in areas of colour with oil pastel.*

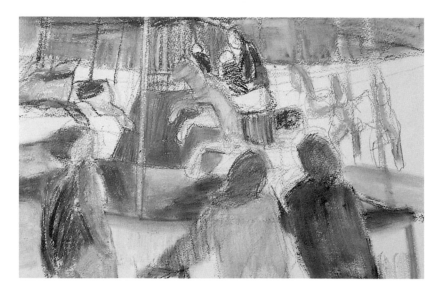

2 *At this stage, the sense of depth and movement within the composition is created by the diminishing size and clarity of the distant horses. They form a strong contrast with the clearly defined dominant figures in the foreground.*

3 *Using a finger, smudge the oil pastel to produce a smooth, even, creamy texture. Smudged oil pastel produces a denser, richer area of colour than soft pastel.*

4 Lift out some of the pastel with a rag to create blurred light areas, which accentuate the movement and establish a space between the foreground figures and the carousel.

5 Build up the detail on the near figures, horses and carousel roof using oil pastels. Then spread the impasto oil bar with a palette knife to give a fragmented, textural effect that further emphasizes the movement.

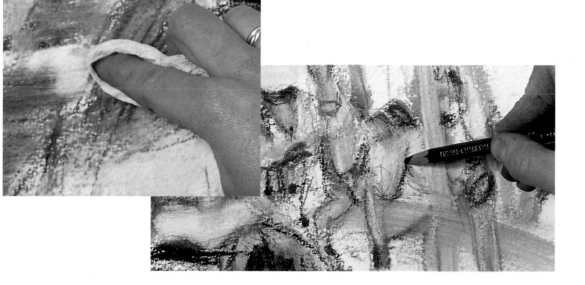

6 Finally, use a pencil to define the detail on the more distant horses and bring any necessary lines and shadows into focus.

◄ **Carousel**
KAREN RANEY
A strong sensation of incessantly rotating motion is achieved by exaggerating the carousel's structural elements: the support poles, horses and axle incline inwards and upwards to the focal point. Repetitive linear strokes follow the carousel's circular structure, while the smudged areas of pastel blur details and contrast with the rigid structural elements.

Index

Credits

Quarto would like to thank all the artists who have kindly allowed us to reproduce their work in this book.

We would also like to acknowledge and thank the following artists for their help in the demonstrations of techniques: Rima Bray (52, 65, 80, 84–5, 96, 127–9; Jean Canter (110–11); Pip Carpenter (40–1); David Carr (39, 64, 68–9, 126–7); Julia Cassels (22, 23, 25, 38, 52, 64, 82–3, 97, 138); Rosalind Cuthbert (52); David Cuthbert (53); Sharon Finmark (65, 67); Ted Gould (114–17); Caroline Penny (26–9); Karen Raney (140–1); Hazel Soan (98–9); Anthony Tuffin (112–13); Jacquie Turner (42–5); Glen Wawman (54–5, 100–1).

The work of Constance Halford-Thompson appears by kind courtesy of The Osbourne Studio Gallery, London.

Location photographs supplied by Ian Howes. All other photographs are the copyright of Quarto.